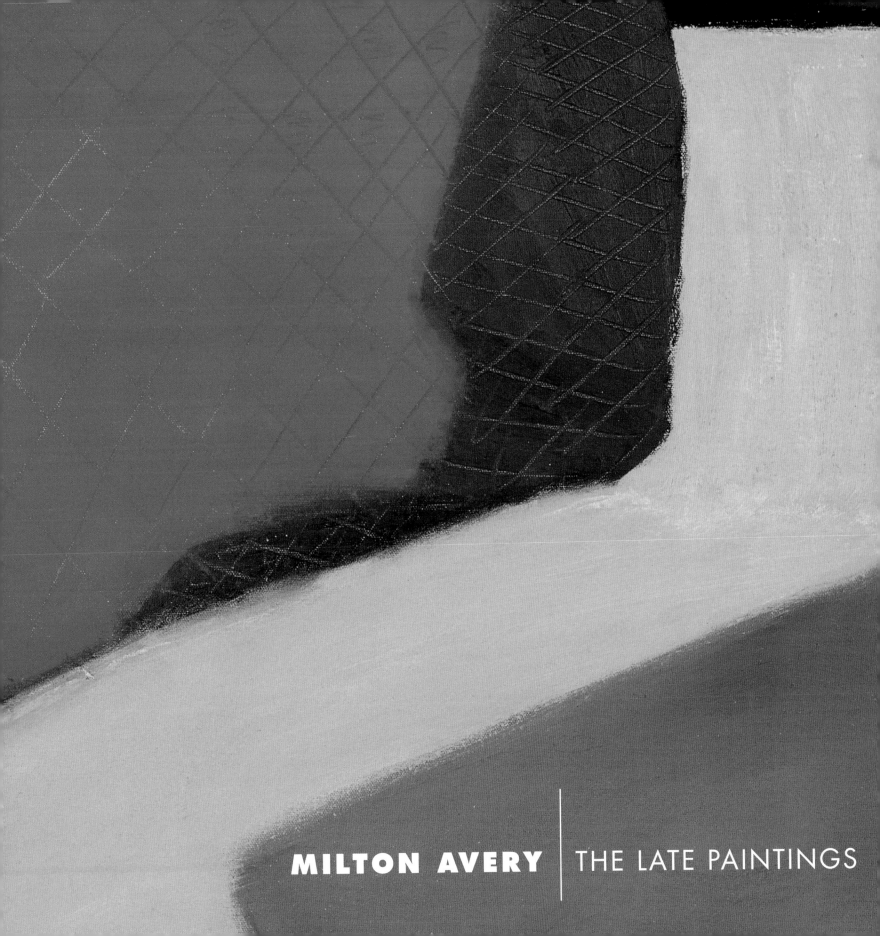

MILTON AVERY | THE LATE PAINTINGS

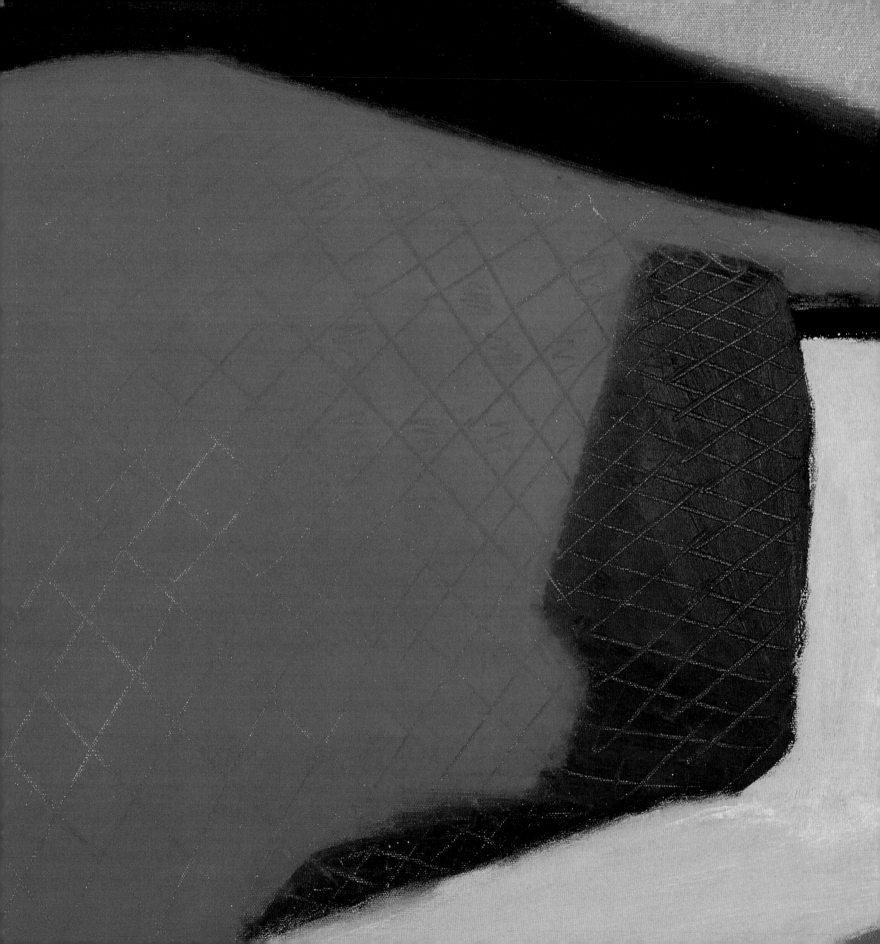

MILTON AVERY | THE LATE PAINTINGS

ROBERT HOBBS

HARRY N. ABRAMS, INC., PUBLISHERS

IN ASSOCIATION WITH

THE AMERICAN FEDERATION OF ARTS

This catalogue has been published in conjunction with *Milton Avery: The Late Paintings,* an exhibition organized by the American Federation of Arts. Support has been provided by the National Patrons of the AFA.

EXHIBITION ITINERARY

MILWAUKEE ART MUSEUM
MILWAUKEE, WISCONSIN
NOVEMBER 30, 2001–JANUARY 27, 2002

NORTON MUSEUM OF ART
WEST PALM BEACH, FLORIDA
FEBRUARY 15–MAY 12, 2002

For the AFA
PUBLICATION COORDINATOR: MICHAELYN MITCHELL

For Harry N. Abrams, Inc.
PROJECT DIRECTOR: MARGARET L. KAPLAN
DESIGNER: RAYMOND P. HOOPER

On the title pages: Milton Avery, *Red Rock Falls* (detail), 1947 (plate 3)
On page 8: Milton Avery, 1963. Photograph Dena Rubenstein, courtesy Knoedler and Company

Library of Congress Cataloging-in-Publication Data

Hobbs, Robert Carleton, 1946–
 Milton Avery : the late paintings / Robert Hobbs
 p. cm.
 Published in conjunction with an exhibition organized by the American Federation of Arts and held at the Milwaukee Art Museum, Milwaukee, Wis., Nov. 30, 2001–Jan. 27, 2002 and the Norton Museum of Art, West Palm Beach, Fla., Feb. 8–May 5, 2002.
 Includes bibliographical references and index.
 ISBN 0-8109-4274-7 — ISBN 1-885444-20-6 (pbk.)
 1. Avery, Milton, 1885–1965—Exhibitions. 2. Avery, Milton, 1885–1965—Criticism and interpretation. I. Avery, Milton, 1885–1965. II. American Federation of Arts. III. Milwaukee Art Museum. IV. Norton Museum of Art. V. Title
 ND237.A85 A4 2001
 759.13—dc21 00–68928

Printed in Japan

10 9 8 7 6 5 4 3 2 1

AMERICAN FEDERATION OF ARTS
41 EAST 65TH STREET
NEW YORK, N.Y. 10021
WWW.AFAWEB.ORG

HARRY N. ABRAMS, INC.
100 FIFTH AVENUE
NEW YORK, N.Y. 10011
WWW.ABRAMSBOOKS.COM

CONTENTS

LENDERS TO THE EXHIBITION

THE BALTIMORE MUSEUM OF ART

BROOKLYN MUSEUM OF ART, NEW YORK

CARNEGIE MUSEUM OF ART, PITTSBURGH

FLINT INSTITUTE OF ARTS, MICHIGAN

HERBERT F. JOHNSON MUSEUM OF ART, CORNELL UNIVERSITY, ITHACA, NEW YORK

MILTON AVERY TRUST, NEW YORK

MILWAUKEE ART MUSEUM

MUNSON WILLIAMS PROCTOR INSTITUTE, MUSEUM OF ART, UTICA, NEW YORK

THE MUSEUM OF MODERN ART, NEW YORK

NATIONAL GALLERY OF ART, WASHINGTON, D.C.

NEUBERGER MUSEUM OF ART, PURCHASE COLLEGE, STATE UNIVERSITY OF NEW YORK

NORTON MUSEUM OF ART, WEST PALM BEACH, FLORIDA

PHILADELPHIA MUSEUM OF ART

THE PHILLIPS COLLECTION, WASHINGTON, D.C.

SHELDON MEMORIAL ART GALLERY AND SCULPTURE GARDEN, UNIVERSITY OF NEBRASKA, LINCOLN

TERRA FOUNDATION FOR THE ARTS, CHICAGO

WHITNEY MUSEUM OF AMERICAN ART, NEW YORK

————

ANONYMOUS

J. BLACK AND R. SCHLOSBERG

LOIS BORGENICHT

MARGO COHEN, COURTESY DONALD MORRIS GALLERY, BIRMINGHAM, MICHIGAN

SIDNEY AND MADELINE FORBES

MR. AND MRS. WALTER KANN, NEW YORK

BERTA BORGENICHT KERR

DONALD AND FLORENCE MORRIS, HUNTINGTON WOODS, MICHIGAN

JANE BRADLEY PETTIT, MILWAUKEE

SANDY AND HAROLD PRICE, LAGUNA BEACH, CALIFORNIA

THE ROLAND COLLECTION

LYNN AND ALLEN TURNER, CHICAGO

MARTIN AND LINDA WEISSMAN, BIRMINGHAM, MICHIGAN

ACKNOWLEDGMENTS

One of America's leading twentieth-century artists, Milton Avery is well known for a pared-down modernism that fuses realism and abstraction. Until now, Avery's oeuvre has been viewed as a monolithic whole. This exhibition and its catalogue, which present the accomplishments of the artist's last two decades as the culmination of a series of successive and distinct periods, constitute a major reassessment of this important body of work.

Our thanks certainly begin with guest curator Dr. Robert Hobbs, who holds the Rhoda Thalhimer Endowed Chair of Art History, Virginia Commonwealth University. The ultimate shape of the exhibition and accompanying publication reflects his connoisseurship and scholarship. We are particularly grateful to him for his perceptive analysis, which provides a fresh look at the work of this important artist.

Dr. Hobbs joins me in thanking all those who have contributed to the realization of this project. On the AFA staff, recognition goes first to Thomas Padon, director of exhibitions, for his strong support of the project. Susan Hapgood, curator of exhibitions, expertly guided every aspect of the exhibition and has been indefatigable in making this exhibition a reality. In tandem with her counterpart at Harry N. Abrams, Michaelyn Mitchell, head of publications, adeptly coordinated the editing and production of this impressive book. Other staff members who share credit for the success of this project include Jennifer Jankauskas, curatorial assistant, who has been deeply committed and instrumental throughout; Karen Convertino and Beverly Parsons, registrars, who handled the challenges of preparing and touring the exhibition; Beth Huseman, editorial assistant, who attended to innumerable details on the publication; Lisbeth Mark, director of communications, and Stephanie Ruggiero, communications associate, who oversaw the promotion and publicity for the project; and Erin Tohill, registrar assistant, who assisted the registrars. Thanks also go to Marie-Thérèse Brincard and Suzanne Ramljak, former AFA curators, for shepherding the project in its earlier stages.

At Harry N. Abrams, the copublisher of this book, our appreciation goes to Margaret Kaplan, senior vice president and executive editor, for her support of this project; and Ray Hooper, the designer, who has created this handsome design.

We are deeply indebted to the following individuals for sharing their knowledge and expertise: March Avery Cavanaugh, Jean Crutchfield, Jeffrey Deitch, Ann Freedman, Christopher Gilbert, Barbara Haskell, Heather McGuire, Ed Wilson, and Dennis Yares.

To the many lenders who so generously allowed us to borrow their paintings by Milton Avery goes our warmest appreciation.

Special thanks are due the venues on the tour—the Milwaukee Art Museum and the Norton Museum of Art, West Palm Beach—for graciously hosting this exhibition.

Finally, we wish to acknowledge the National Patrons of the AFA for their generous support of this exhibition.

Julia Brown
Director
American Federation of Arts

ROBERT HOBBS GRATEFULLY DEDICATES THIS BOOK TO RHODA AND CHARLES THALHIMER

MILTON AVERY | THE LATE PAINTINGS

BY ROBERT HOBBS

The enormously successful 1982 retrospective of Milton Avery's art at New York's Whitney Museum of American Art attracted lines of people outside the museum, often the length of a full city block, and ratified his popular success as a modern American master.[1] Lauded for his bold experiments with color, Avery gained a reputation for paintings in which a wry visual wit joins aspects of realism with abstraction.

Almost twenty years earlier, two of Avery's friends since the late 1920s and 1930s, the highly respected Abstract Expressionists Adolph Gottlieb and Mark Rothko, attested to his enormous stature, and thus paved the way for the Whitney showing. Gottlieb noted the contradiction that Avery's "last works . . . were as fresh as though he were a young painter" while having "the authority of an old master." From this he concluded, "Avery is one of the few great painters of our time."[2] His estimation is indeed high praise, for Avery would still have been considered his competitor. Three years later, at a memorial service for Avery, Rothko delivered the eulogy:

This conviction of greatness, the feeling that one was in the presence of great events, was immediate on encountering his work. . . .

Avery is first a great poet. His is the poetry of sheer loveliness, of sheer beauty. . . . This—alone—took great courage in a generation which felt that it could be heard only through clamor, force and a show of power. . . . There have been several others in our generation who have celebrated the world around them, but none with that inevitability where the poetry penetrates every pore of the canvas to the very last tip of the brush. For Avery was a great poet inventor who invented sonorities never seen nor heard before. From these we have learned much and will learn more for a long time to come.[3]

These high commendations led to the observation by the critic Dore Ashton that Milton Avery enjoyed the rare distinction of being a painters' painter:

I came to understand that painters' painters were those for whom painting was meant not just to solve problems, but to be offered for delectation. . . . Milton Avery . . . published no manifestos, indulged in no polemics and followed his bent imperturbably while all around him artists were agonizing over crucial choices amongst the many possible twentieth century modes of vanguardism. For that reason, undoubtedly, he was considered by many as something of a primitive, a kind of Rousseauan pure soul who did what he did out of innocence. That, of course, was a mistaken view. Avery as a painter was nothing if not sophisticated.[4]

These statements were intended to be generous homages to an enormous and deserving talent. But the fact that they represent a large body of similarly oriented articles and catalogues on Milton Avery should give us pause. These publications extol Avery's prowess as a painter, his poetic color, his piquant forms, and his dazzling wit; however, they do not attempt to explain how his work fits into a historical context. The problem with this type of approbation, focusing primarily on the formal aspects of his art, is that it has removed it from historical analysis. Unfortunately, most writings on Avery have not provided a means for understanding the artistic challenges he posed for himself, the routes he avoided, and the way he often deflected competing aesthetic theories through subtle and witty pastiches.[5] This celebratory literature has also looked at Avery's work as a monolithic whole, so that the changes in his art have been glossed over, while both its participation in some of the social forces of its time and criticism of others have been denied a place in his history.

In order to provide a fuller appreciation of Avery's historical position, this book distinguishes four periods in his work. Born in 1885, he served an extremely long art apprenticeship when he lived in Connecticut and developed a variant on American Impressionism. The first period thus starts between 1905 and 1911 and continues through 1924. His second stage of development, which can be termed his "early mature phase," occurs between 1925 and 1937. At this time he was living and working in New York City and initially came in contact with European modernism. His full maturity commences in 1938, when he made several hundred watercolors on the Gaspé Peninsula in southern Quebec, Canada. During this period he became known as the "American Fauve." This time concluded after the end of World War II, when he had so internalized lessons learned from the Fauves that he was able to move away from their manner. His late work—the subject of this book—begins in 1947, with his retrospective exhibition at Durand-Ruel Galleries in New York, entitled, "My Daughter March," in which he surveyed both his

own development and his daughter's life. This final period, which is notable for its extreme simplification of forms and cogent interplays of realism and abstraction, draws to a close in 1963, when ill health forced Avery to stop painting.[6] It is a remarkable time of exploration during which his artistic forays mined the explorations of the American modernist poet Wallace Stevens.

This book's primary goal is to locate Milton Avery's late works within the context of the contested field of mid-twentieth-century art in the United States. My focus on the late work allows for more extended and intensive discussions of this important period.[7] The artistic context of Avery's late paintings comprises his relationships with his peers; his conversations with competing styles, including the radical revision of French Impressionism in the 1950s; and ways of approaching the post–World War II American anti-Communist political policy and ideology known as containment. In order to access this theater of stylistic options and subtle ideological coercions, I begin by examining the singularly important essay on Avery's art written by Clement Greenberg in 1957. This article maps out the ideological territory in which the artist's late work was created by outlining the historical nexus in which Avery developed and the ongoing discourses to which his work responds. First published in the December 1957 issue of *Arts*, Greenberg's essay was revised in 1958 for a 1961 collection of his writings entitled *Art and Culture*.[8] Later, Waddington Galleries in London used it as the text for Avery's fall 1962 exhibition.

I next look closely at an important discourse that Greenberg's essay does not explore: the place of modern poetics in the formation of Avery's theory regarding the countervailing roles of abstraction and realism. In order to form an adequate picture of Avery's visual poetics, I investigate his art's connections with both Henri Matisse's painting and drawing and Wallace Stevens's poetry. In addition, I consider the direct impact of Stéphane Mallarmé's ideas on the work of Matisse and Stevens and the indirect influence these concepts in turn had on Avery's art. My aim is to fill major gaps in our understanding of Milton Avery's painting, so that it will no longer appear as an idiosyncratic oeuvre, unrelated to the times in which it was created.

CLEMENT GREENBERG AND MILTON AVERY

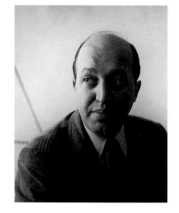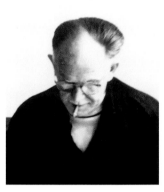

FIG. 1. CLEMENT GREENBERG, CA. 1940S. PHOTOGRAPH JERRY COOKE, COURTESY JANICE VAN HORNE

FIG. 2. MILTON AVERY, PROVINCETOWN, MASSACHUSETTS, 1958. PHOTOGRAPH PHILIP CAVANAUGH, COURTESY KNOEDLER AND COMPANY

In 1956, Jackson Pollock died in an automobile accident, and many people saw this as Abstract Expressionism's *terminus ad quem*. Clement Greenberg, who had been Pollock's major champion and critic, was unable to forgive him for the death of a young woman that was a result of his reckless driving.[9] For this reason, he began looking for a successor who would represent different values. The following year, in an article in *Arts* he proposed Milton Avery as the artist most capable of influencing the next new wave.[10] Ostensibly a critical piece responding to Avery's recent show at the Grace Borgenicht Gallery in Manhattan, Greenberg's article was actually a carefully orchestrated bid to redirect history. It viewed Avery as the precursor of a new type of painting, predicated on the opticality of color and capable of replacing—or at least diverting attention from—the tactility of Cubist paintings and collages that had constituted the dominant modern tradition since the beginning of the twentieth century.[11]

FIG. 3. ADOLPH GOTTLIEB, *BURST*,
1957. OIL ON CANVAS, 96 X 40
INCHES. ADOLPH AND ESTHER
GOTTLIEB FOUNDATION, INC.

Greenberg was excited by the exhibition because it contained Avery's first series of large-format canvases.[12] On his yearly Labor Day visit to the Abstract Expressionist painter Hans Hofmann's home and studio in Provincetown, Massachusetts, Greenberg had been able to review Avery's summer work and prepare himself for this fall exhibition.[13] He reproduced several of the new pieces in his essay together with a number of works from the 1940s, to provide a greater understanding of Avery's development. Two of the most notable 1957 paintings are the large *White Moon* (plate 32), and *Poetry Reading* (plate 29). The former reflects a new development in Avery's art and also responds to new paintings by Gottlieb, who that year had initiated the series known as the *Bursts* (fig. 3). Characterized by contrasts between giant orbs and calligraphically painted scrawls, these paintings suggested to many critics primordial oppositions of heavenly bodies and earth. While Gottlieb preferred to create mythic paintings with atavistic associations, Avery maintained connections with American Scene painting when he depicted

the moon over Provincetown Bay in a condensed fashion. In this and other works his approach is both realistic and abstract, traditional and innovative. These ostensibly contrary qualities were to make him particularly useful to Greenberg's strategy to redirect history. No doubt Greenberg was impressed by formal similarities between Gottlieb and Avery, and this correspondence may have been one reason for his intrigue with the latter. Also, Greenberg's regard may have been swayed by the high esteem in which Avery's work was held by Barnett Newman and Mark Rothko, two of the major Color Field Abstract Expressionists.

Although not large in comparison to the wall-size forays of the Abstract Expressionists, Avery's ample easel pictures provided Greenberg with an opportunity to attribute to him the beginnings of a tradition that he had been assessing for more than a decade. Starting in the late 1940s Greenberg had discerned a lighter and more delicate approach in the Abstract Expressionist paintings by Arshile Gorky and Jackson Pollock. The latter had experimented with staining techniques to allude to natural effects in such works as *Number 1, 1950 (Lavender Mist)* (fig. 4) and *Autumn Rhythm* (both 1950). This approach influenced Greenberg's companion in the early 1950s, the young painter Helen Frankenthaler. She transformed these traces into a

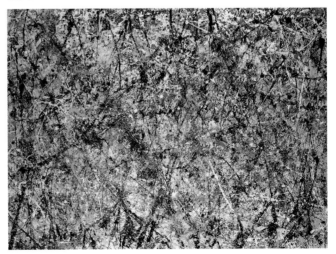

FIG. 4. JACKSON POLLOCK, *NUMBER 1, 1950 (LAVENDER MIST)*, 1950. OIL, ENAMEL,
AND ALUMINUM ON CANVAS, 87 X 118 INCHES. NATIONAL GALLERY OF ART,
WASHINGTON, D.C.; AILSA MELLON BRUCE FUND

PLATE 1. *ADOLESCENCE, 1947*

PLATE 2. *BOW RIVER, 1947*

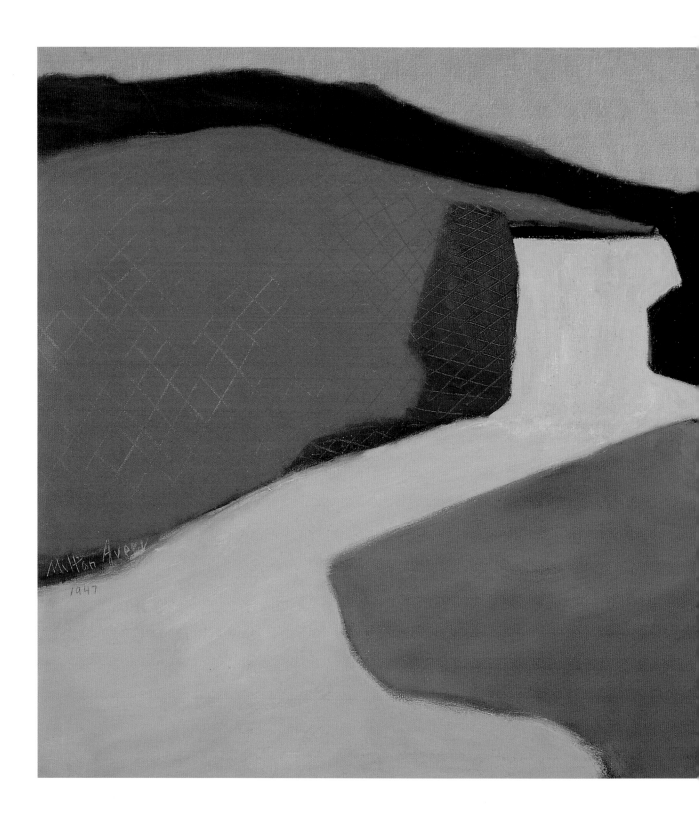

full-fledged oeuvre of stained canvases. Greenberg then introduced Morris Louis and Kenneth Noland, both Washington, D.C.–based painters, to Frankenthaler's work. In the spring of 1953 the two visited her studio, where they saw her first major stained canvas, *Mountains and Sea* (fig. 5), which she had completed the year before.[14] This viewing, together with Greenberg's analysis of its historical significance, assumed the force of a revelation. Color Field painting was born; soon thereafter the style separated from its Abstract Expressionist precursors (fig. 6).

Avery used aspects of this approach before the Color Field artists: painting thinly with luminous, transparent washes that reinforced the flatness of the canvas. He differed from them, however, in priming his canvases. Since Greenberg cited him in support of his aesthetic theories, it is helpful to look closely at his strategies. As we will see, his ideas have had a distinct bearing on Avery's stature.[15] In addition to its explication of Avery's importance, Greenberg's reasoning constitutes a series of responses to an ongoing discourse on modern art in the late fifties, when Avery was culminating his late style and other artists were struggling to establish currents that might be accepted as definitive.

Greenberg's essay may be used as a means for assessing what the French sociologist and theorist Pierre Bourdieu terms "the artistic field."[16] Bourdieu describes this domain as a contested terrain in which different players compete for control of a particular aesthetic point of view. Such a theory necessitates a program of (1) locating the area to be investigated within a field of power relations; (2) discerning the pattern of these relations; and (3) disclosing the trajectories of artistic activity to see how socially constructed traits act as guides. This historical process is twofold since it describes both the place of artists in the field and the stances they adopt. Bourdieu's theory places primary importance on the way artists jockey for power in any given social context; this may also apply to the way critics function. Indeed, Greenberg's essay articulates the field of power relations in which he perceives Avery's art to operate. Bourdieu takes into consideration the constraints imposed on artistic production by

PLATE 3. *RED ROCK FALLS*, 1947

FIG. 5. HELEN FRANKENTHALER, *MOUNTAINS AND SEA*, 1952. OIL ON CANVAS, 86⅝ X 117¼ INCHES. COLLECTION OF THE ARTIST, ON LOAN TO THE NATIONAL GALLERY OF ART, WASHINGTON, D.C.

FIG. 6. MORRIS LOUIS, *AYIN*, 1958. ACRYLIC RESIN (MAGNA) ON CANVAS, 97½ x 140¾ INCHES. THE ART GALLERY OF NEW SOUTH WALES, SYDNEY, AUSTRALIA

competing ideological positions; similarly, we may look at Greenberg's essay to see which ideological positions he deems important to Avery. For example, Greenberg overlooks the works of Gorky, Pollock, and Frankenthaler and the painting styles developed by Newman and Rothko in his effort to gain support for his own views regarding Avery's preeminence. Instead of observing art in terms of simple interactions resulting in collective endeavors, Bourdieu considers it as a battleground for competing worldviews—or we might say, for socially constituted systems that motivate conduct while naturalizing it as reasonable and logical. This theory will help us construct the historical stage on which Avery's art performs.

At the beginning of his essay Greenberg qualifies Avery's stature by pointing out that while his art may be a crucial milestone on the route to Color Field painting, it should not be considered its culmination. He characterizes Avery as "daring but unspectacular," probably because he intended to champion the younger Louis and Noland, who carried their investigations to a point that he deemed definitive. He explains that his decision to choose Avery for special recognition rested on his ability to provide "specific lessons for painters today."[17] Greenberg's linkages enable us to understand the dialogic nature of Avery's art, which responds to numerous artistic currents, from Albert Pinkham Ryder's form of abstraction to Impressionism and Fauvism. It is

implicitly critical of others, including Jackson Pollock, and totally unconcerned with still others, such as the emergent Pop productions of Jasper Johns, Robert Rauschenberg, and Larry Rivers.

Greenberg situates Avery as a purely American painter, well aware of his artistic heritage, but not constrained by it. He points out Avery's affinities with American Scene painters, although he calls them "misguided and obscurantist" and does not refer to either the Midwestern Regionalists or the Socialist Realists by name. He then goes beyond American Scene painters by commenting that Avery "look[ed] harder at Ryder and some of the American Impressionists than at any French art."

Albert Pinkham Ryder had been named by Pollock as a formative influence,[18] and extolled in the first half of the twentieth century as one of America's foremost geniuses. He was called "the Thoreau of painting" and "the Whitman of the brush."[19] Following his death in 1917, the Metropolitan Museum of Art in New York honored him with a memorial retrospective exhibition. In 1930 the new Museum of Modern Art in New York (hereafter MoMA) grouped him with the canonical Thomas Eakins and Winslow Homer in a three-person exhibition. Ryder's work was shown infrequently in New York galleries in the 1930s and 1940s, and he had an important Whitney Museum retrospective in 1947 curated by Lloyd Goodrich. This exhi-

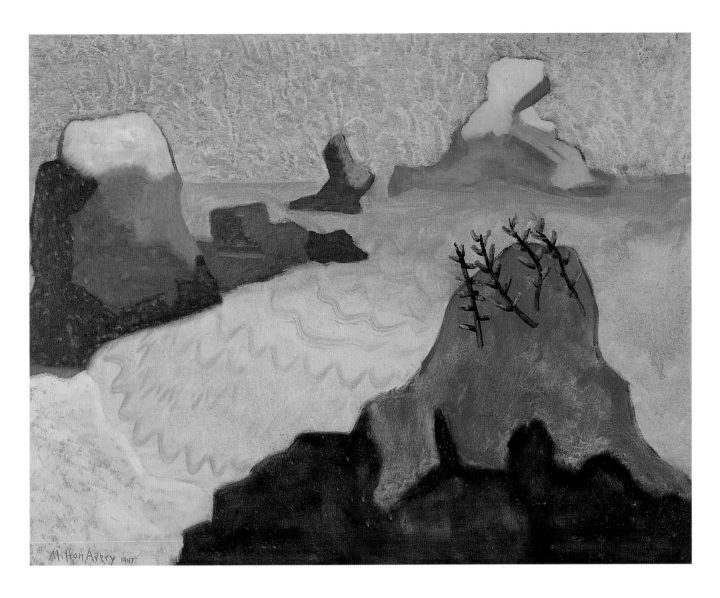

PLATE 4. OREGON COAST, 1947

bition gave careful attention to the originality of the works. It included X-rays of paintings demonstrating their authenticity and photographs of attempted forgeries to underscore the subtlety of his pared-down forms. This display helped to ratify Ryder's importance, since only Camille Corot was said to have had more forgeries made of his art.

At the time, *Art News* published a series of statements testifying to Ryder's continued preeminence, collected from several deans of American painting, including Avery's old friend Marsden Hartley, as well as Reginald Marsh and Walt Kuhn.[20] Hart-

ley wrote, "If America is to have a great tradition, it will begin with the great and lasting name of Albert Pinkham Ryder." In an effort to assess Ryder's formal significance, Kuhn noted, "He had the great gift of knowing how to put tone to tone. That's hard to do—and maybe that's why he's had so few direct followers. . . . Look at Ryder's designs. They fit like gears . . . it all interlocks."[21]

The influence of Ryder on Avery's late works is striking (fig. 8). In a number of them, such as *Poetry Reading* and *Plunging Gull* (1960; plate 49), he undertook the task of creating tonal pieces instead of working only with saturated hues, as had been

FIG. 7. MILTON AVERY, 1951. PHOTOGRAPH LEE SIEVAN,
COURTESY KNOEDLER AND COMPANY

FIG. 8. ALBERT PINKHAM RYDER, *MOONLIGHT MARINE*, CA. LATE 1890S.
OIL AND POSSIBLY WAX ON WOOD, 11½ X 12 INCHES.
THE METROPOLITAN MUSEUM OF ART; SAMUEL D. LEE FUND, 1934 (34.55)

his practice. This was a remarkable and daring course for a painter who had been broadly acknowledged in the 1940s as the quintessential "American Fauve." He also continued to use interlocking forms, as he had done in the 1930s. These interconnected forms became increasingly important in his later years, when his canvases resembled giant, luminous jigsaw puzzles with only a few components. Pertinent examples of paintings incorporating these interconnected forms include *Red Rock Falls* (1947; plate 3), *Summer Reader* (1950; plate 9), *Shapes of Spring* (1952; plate 15), and *Dark Forest* (1958; plate 39).

Also writing in *Art News*, Reginald Marsh pointed out that although Ryder made all his work in the studio, he understood "how the halo looks around the moon, and what moonlight does to objects, and how a wave turns over" (fig. 8). [22] His description could apply equally to the mixture of realism and abstraction found in Avery's nocturnal scenes—*White Moon, Black Night* (1959; plate 44), and *Tangerine Moon and Wine Dark Sea* (1959; plate 42).

A few years later, seventeen Ryders were shown at the Smithsonian Institution in Washington, D.C. *Life* magazine hailed the exhibition as an event of national interest, and published an extended article on Ryder by Winthrop Sargeant, with color reproductions. Greenberg understood Ryder's particular status when he linked his work with Avery's. Many of Ryder's paintings are astonishingly abstract and may be said to confer on Avery permission to create his own condensed views of the

world. A particularly telling example is *Sail* (1958); a less obvious but still significant one is *Black Sea* (1959; plate 43). In Greenberg's circuitous reasoning traits in Avery were labeled American by virtue of comparisons made with such artists as Ryder, acknowledged creators of an American style.

In 1957 the concept of an American style had political overtones. The United States was still recoiling from an identity crisis fomented by the 1954 Army–McCarthy anti-Communist hearings in Congress. In October 1957 the Russians had launched Sputnik, the first satellite in space. Although it was considered a top-ranking international power, the United States was suffering the initial effects of the Cold War that polarized the planet into eastern and western factions after World War II. Nationalism was a timely but contentious topic. In this climate Jasper Johns painted his first *Flags* (fig. 9) and Greenberg titled a major article "American-Type Painting" (1955). [23] In his Avery essay Greenberg's chauvinism continued to be unabashed. "The general impression," he writes, "is still that an art of high distinction has as much chance of coming out of this country as a great wine. Literature—yes, we know that we have done some great things in that line; the English and French have told us so. Now they can begin to tell us the same about our painting." [24]

Perhaps because he himself was an old politico with strong leftist tendencies, Greenberg was sensitive to issues of nationalism and its perceived enemy, communism. He no doubt appreciated Avery's own political activism in the 1930s, when he had

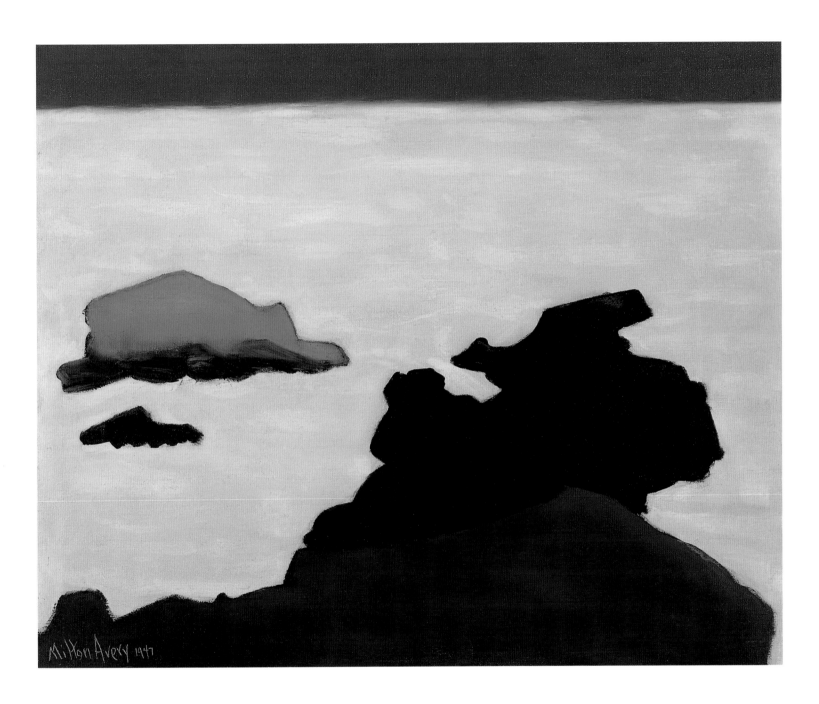

PLATE 5. *WHITE SEA, 1947*

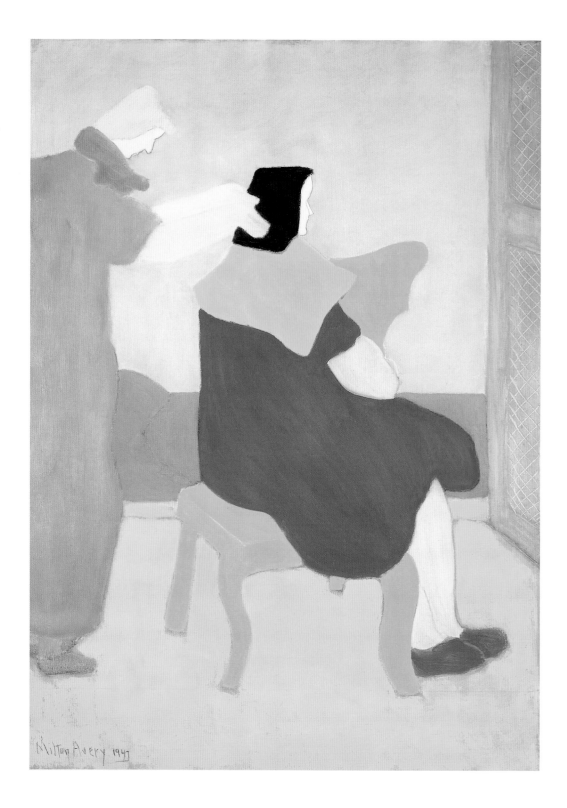

PLATE 6. *THE HAIRCUT*, 1947

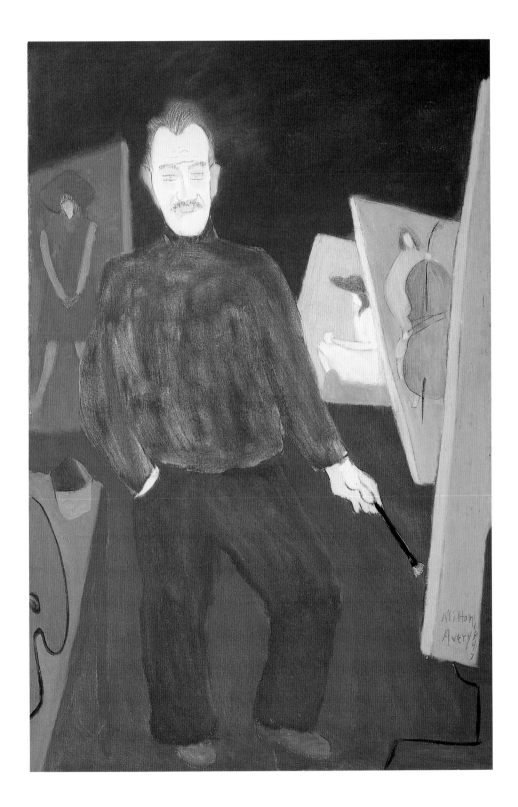

PLATE 7. *SELF-PORTRAIT,* 1947

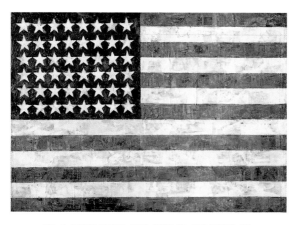

FIG. 9. JASPER JOHNS, *FLAG*, 1954–55. ENCAUSTIC, OIL,

AND COLLAGE OF FABRIC MOUNTED ON PLYWOOD, 42¼ X 60⅝ INCHES.

THE MUSEUM OF MODERN ART, NEW YORK;

GIFT OF PHILIP JOHNSON IN HONOR OF ALFRED H. BARR, JR.

belonged to the left-wing American Artists' Congress.[25] He further understood that in the 1950s an unassailable American pedigree was essential to Avery's status as progenitor of the new Color Field school.

Greenberg therefore poised Avery between tradition and innovation, nationalism and internationalism. This nationalist outlook forms the ideological backdrop for his essay as well as for Avery's work. He declares, "When [Avery] did go on to assimilate French influences, the outcome was still some of the most unmistakably and authentically American art that I, for one, have seen."[26] He observes that Avery was unimpressed with Americanness as an aesthetic category, and adds, "If his art is so unmistakably American, it is because it embodies so completely and successfully the truth about himself and his condition."

In this article Greenberg makes a reference to American Impressionism that must be understood within the mid-twentieth-century landscape of ideas in which he was writing, particularly since works of Avery's first period belong to the Impressionist style. French Impressionism's impact on contemporary art had been dramatically reconsidered in the early 1950s, so that it could be incorporated into the history of modernism. Its former reputation as a charming form of bourgeois art was replaced by a concept of it as radically optical and incipiently abstract. When MoMA acquired its first two Claude Monet paintings of water lilies in the 1950s (fig. 10), critics and artists alike began to see connections between these early-twentieth-

century works and the most advanced post–World War II art. Almost overnight, Impressionism came to be regarded as a relevant style, and Monet was hailed as the equal of Paul Cézanne, who had been the undisputed father of modern art. Writing in 1956, the critic Hilton Kramer pronounced, "The process of reconstructing Monet into an avant-garde master of heroic dimensions [seems] now [to be] in full swing."[27] John Canaday's 1959 textbook *Mainstreams of Modern Art* confidently compared a late Monet with Jackson Pollock's *Autumn Rhythm*, including a detail of Monet's brushwork as proof of its undisputed precursory impact on Abstract Expressionism.[28]

Impressionism was rehabilitated in the 1950s with remarkable ease and rapidity. Looking back on this time, Irving Sandler pointed out in the 1970s that "the Impressionist component in the gesture painting of the second generation [of the New York School] . . . more than anything else distinguishes it from that of the first."[29] Sandler, however, was still so immersed in the period that he saw no need to explain why he considered this seemingly reactionary move an advance.

One of the first statements reconsidering Impressionism occurred in 1953, when MoMA exhibited a recently acquired Monet in its summer show. The Abstract Expressionist Barnett Newman, whose *Zip* paintings were in part influenced by the poet and critic Jules Laforgue's nineteenth-century critique of Impressionism,[30] wrote strongly worded letters on July 3 and July 20 to the president of the museum's board of trustees. In them he demanded that MoMA openly admit its past misrepresentation of Impressionism, rather than bury its reassessment in a summer show. By 1954 the point was made, and the young art historian Robert Rosenblum remarked, "One wearies . . . of looking at these [Impressionist] masters in the narrow terms of their contributions to modern (read *abstract*) art." Yet he was quick to admit that there are a number of "unexpected analogies" between the two, causing one to rethink the work of Rothko, Pollock, and Philip Guston.[31] To this list Avery's name should be added. Two years later, the critic and editor of *Art News*, Thomas B. Hess, named André Masson, Ad Reinhardt, Mark Tobey, and Clyfford Still as artists who had benefited from a rigorous rethinking of the late work of the Impressionists in general, and of Monet in particular.[32]

So widespread was the reconsideration of Monet in the mid-1950s that Hess termed it a fad. On November 30, 1955, the *New York Times* announcement of the MoMA acquisition of Monet's *Water Lilies* noted that "its inclusion is made on the ground that its style might be called abstract Impressionist" and that this late work was of increasing importance to young abstract painters.[33]

This acquisition forms a basis for Greenberg's important reconsideration of Impressionism's contributions to modern art in "American-Type Painting." Here, he pits the radical color values found in the works of Pierre Bonnard, Monet, and Edouard Vuillard against Cubism's conservative dark-and-light contrasts. He finds Clyfford Still's painting (fig. 11) representative of a new understanding of both Monet and Camille Pissarro. "Recently, however," he writes, "some of the late Monets began to assume a unity and power they had never had before. . . . As the Cubists resumed Cézanne, Still has resumed Monet—and Pissarro. His paintings were the first abstract pictures I ever saw that contained almost no allusion to Cubism."[34] In Greenberg's reassessment, Impressionism and its immediate followers, the Nabis, are predictive of a whole new area of formal invention. In 1957, the same year as his article on Avery, Greenberg wrote a piece on Monet for *Art News Annual*, probably in response to an October 1956 exhibition of Monet's late paintings at the Knoedler gallery and several prominent recent American purchases of the artist's *Water Lilies*. Not surprisingly, he regards Monet's elimination of value contrasts especially significant. He finds that *Rouen Cathedral, Sunlight* (1894; Museum of Fine Arts, Boston) and *Pond and Covered Bridge* (ca. 1919; Museum of Modern Art) both demonstrate why Monet's "free, calligraphic brushwork and loose, tonal delineation of form [are] influencing today's Abstract-Impressionism."[35]

In March 1956, the artist and critic Louis Finkelstein wrote an article for *Art News*, describing the artistic development then being referred to as "Abstract Impressionism."[36] The term is also used by the artist and critic Elaine de Kooning (fig. 12), in her article "Subject: What, How or Who?" published in the April 1955 issue of *Art News*. De Kooning notes that there are twice as many Abstract Impressionists as Abstract Expressionists, even though the former are rarely mentioned. She points out that the

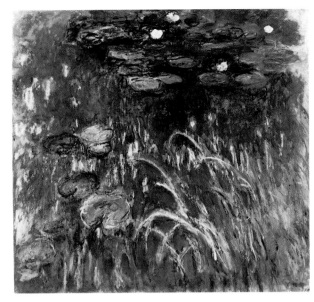

FIG. 10. CLAUDE MONET, *WATER LILIES*, 1916–20 (DESTROYED BY FIRE, APRIL 1958). OIL ON CANVAS, 70⅞ X 79 INCHES. FORMERLY COLLECTION OF THE MUSEUM OF MODERN ART, NEW YORK

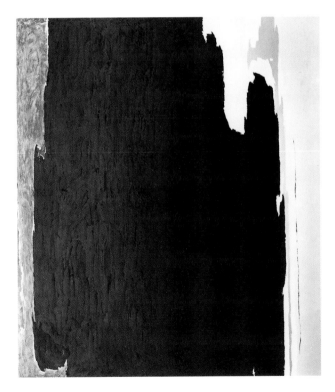

FIG. 11. CLYFFORD STILL, *PAINTING*, 1951. OIL ON CANVAS, 94 X 82 INCHES. THE MUSEUM OF MODERN ART;BLANCHETTE ROCKEFELLER FUND

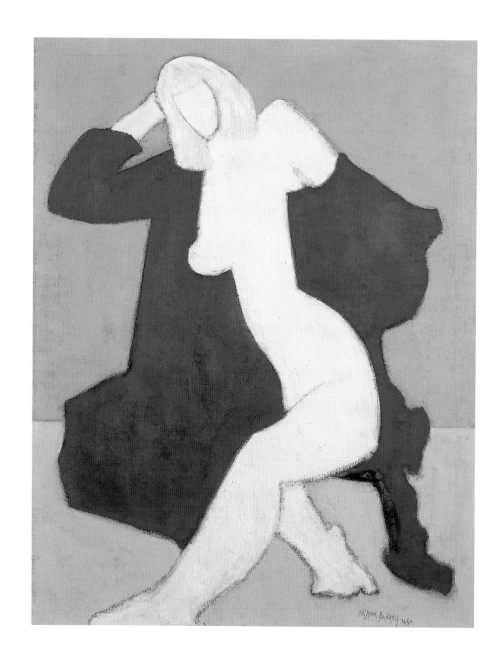

PLATE 8. *NUDE IN BLACK ROBE*, 1950

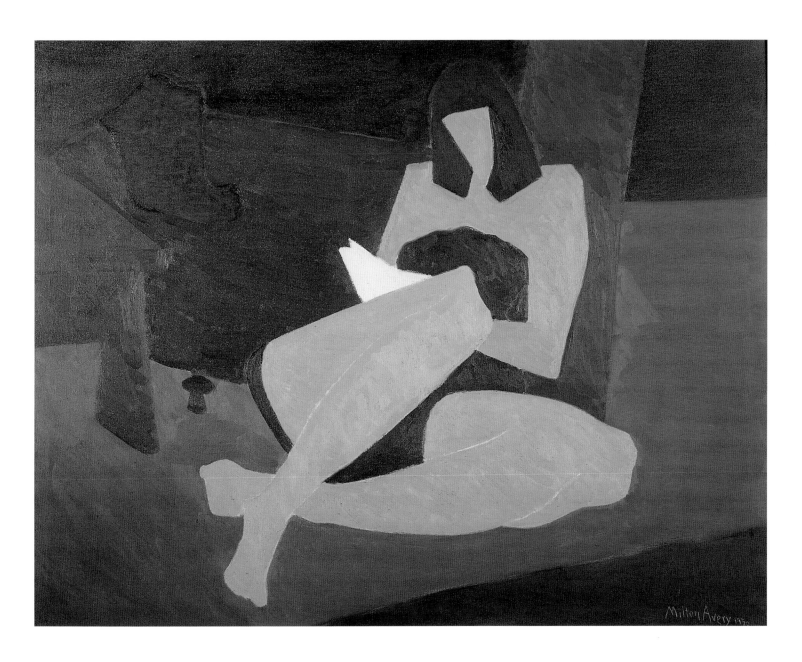

PLATE 9. *SUMMER READER, 1950*

Abstract Impressionists tend to create all-over compositions through "the quiet, uniform pattern of strokes that spread over the canvas without climax or emphasis." In her opinion, they banish the traditional subject matter that interested the Impressionists and instead attempt to manifest "spiritual states" through resolutely optical means.

Several critics posed the question of whether this 1950s quasi-revivalist style should be considered an eradication of realism, and in a manner characteristic of the time, they hedged on this point. De Kooning regards art itself as an available subject matter for painters, on a par with nature. "If one does not want to paint a still-life or a landscape or a figure now," she muses, "one can paint an Albers or a Rothko or a Kline. They are all equally real visual phenomena of the world around us."[37] The critic and figurative painter Fairfield Porter reinforces this idea: "The Impressionists taught us to look at nature very carefully; the Americans teach us to look very carefully at the painting. Paint is as real as nature and the means for a painting can contain its ends."[38]

Since Finkelstein interprets "abstract" to include images "drawn from reality," he connects figurative artists with abstract painters. His list of those who cross this divide includes Nell Blaine, Robert De Niro, Robert Goodnough, Philip Guston, Wolf Kahn, Joan Mitchell, Stephen Pace, and Miriam Schapiro. He remarks, cryptically, that "the label [Abstract Impressionist] comments on how abstract (unreal) it looks, yet it seems also to work in reverse—making a number of abstract paintings look more real." He readily admits that "the tie to representation which Impressionism implies is equivocal or irrelevant, but the kind of vision in which [these artists] are involved is basically Impressionist, recasting abstraction into something much more concerned with the qualities of perception of light, space and air than the surface of the painting." However, he points out that this art is "moving towards rather than receding from reality."

Crucial to this art is the primacy of seeing, which replaces the Abstract Expressionist concern with process, personal autonomy, psychology, myth, and existential angst. Finkelstein writes, decisively, "It is this quality of responding to vision as well as the importance of seeing for seeing's sake which links these, and many other artists working along similar lines, with Impression-

FIG. 12. RUDY BURCKHARDT, *ELAINE DE KOONING IN FRONT OF DRAWING FOR "WOMAN I,"* 1950. GELATIN-SILVER PRINT, 8 X 8 INCHES. COURTESY TIBOR DE NAGY GALLERY, NEW YORK

ism."[39] On a similar note, Hilton Kramer describes the role of sensation in Monet's art as a special distillate of perception and feeling: "It was nothing less than the fluidity of sensation itself which came ultimately to occupy the center of Monet's interest—sensation perceived as a continuous interweaving of the particles of experience, unfettered in its headlong course by any single moment of perception and the memory of perception impinging upon and submitting to the sweet flux of all sensation as it unfolds itself to the senses."[40]

To say that Impressionism constitutes the essence of seeing was not new; Jules Laforgue had expressed the idea in the 1880s. In 1956 *Art News* published an English translation of one of his major essays under the title "Impressionism: The Eye and the Poet."[41] Laforgue writes:

Essentially the eye should know only luminous vibration, just as the acoustic nerve knows only sonorous vibration. The eye, after having begun by appropriating, refining and systematizing the tactile faculties, has lived, developed and maintained itself in this state of illusion by centuries of line drawings; and hence its evolution as the organ of luminous vibration has been extremely retarded in relation to that of the ear, and in respect to color, it is still a rudimentary intelligence.

The Impressionist eye, he declares, represents a new understanding of vision. It is the "natural eye—or a refined eye, for this organ, before moving ahead, must first become primitive again by ridding itself of tactile illusions [so that] it reaches a point where it can see reality in the living atmosphere of forms, decomposed, refracted, reflected by beings and things in incessant variation." This eye is the most evolved in existence. Writing in 1964, Porter reiterates Laforgue's claim that the Impressionists created the first works to be almost entirely responsive to sight. Only recently, he says, have New York painters returned art to seeing, and the radicalness of Impressionism's innovations been fully appreciated.[42]

Before Porter, Greenberg affirmed the importance of optical art in his essay on Avery. His comments on Avery's grounding in the American variant of Impressionism set the course for his discussion. Looking at the painter in terms of the recent discourse on French and Abstract Impressionism, he marshaled a series of proofs of his indisputable opticality. He paraphrases an observation in the 1952 Avery retrospective exhibition catalogue by Frederick S. Wight that this artist's work is distinctive for "its insistence on nature as a thing of surfaces alone, not of masses or volumes, and as accessible only through eyes that refrain from making tactile associations."[43]

The rubric "American Impressionist" was a tactic for joining opticality with nationalism, rather than associating Avery with the American nineteenth-century painters working in France. But despite Greenberg's particular ambitions, the term has since taken on new relevancy because of the important revisionist work on this topic.[44] In his early years Avery had fully participated in the Connecticut branch of the American Impressionist school, when he lavishly applied paint with a palette knife to his canvases. Critics compared his textures to crushed jewels and cited the name of the New York Impressionist Ernest Lawson as a precursor (fig. 13).[45] This legacy is important to our understanding of the trends in the 1950s that Greenberg stressed, subverted, or ignored in his efforts to establish a position of primacy for Avery.

The Avery family had lived in the Connecticut village of Windsor, near East Hartford, since 1898. Avery became aware of Impressionism sometime between 1905 and 1918, when he was

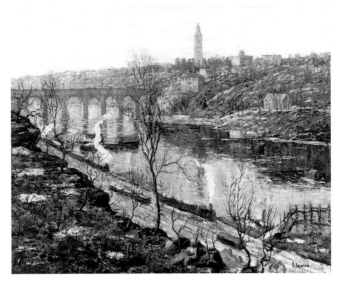

FIG. 13. ERNEST LAWSON, *HIGH BRIDGE, HARLEM RIVER*, CA. 1910. OIL ON CANVAS, 40 X 50 INCHES. SAN ANTONIO MUSEUM OF ART; PURCHASED WITH ELIZABETH AND GEORGE COATES FUND

enrolled in life-drawing classes at Hartford's Connecticut League of Art Students and, later, the School of the Art Society. This period coincided with the peak of American Impressionism. The movement is said to have begun in the early 1890s, when the American frontier closed, and to have ended around 1925, giving way to competing new styles. Among the prominent Connecticut Impressionists are Childe Hassam, John Twachtman, and J. Alden Weir; this regional school boasted two summer colonies, in Cos Cob and Old Lyme.

The contemporaries of American Impressionism liked it for its emphasis on modest, settled landscapes, family pleasures, and home. In these works the realities of the external world of labor were carefully excluded. Although seemingly democratic in perspective, the depictions of the sparsely settled suburban locales presented rarefied and harmonious environments that exuded a hothouse atmosphere. Avery's later, abstracted landscapes tended to perpetuate this ambience, albeit in a disguised form. In Connecticut he would have known these paintings, as well as the intimate, darker landscapes of J. Francis Murphy, whose art he particularly admired.[46]

Connecticut Impressionism was part of a larger restructuring of the American concept of landscape. The art historian Lisa N. Peters writes:

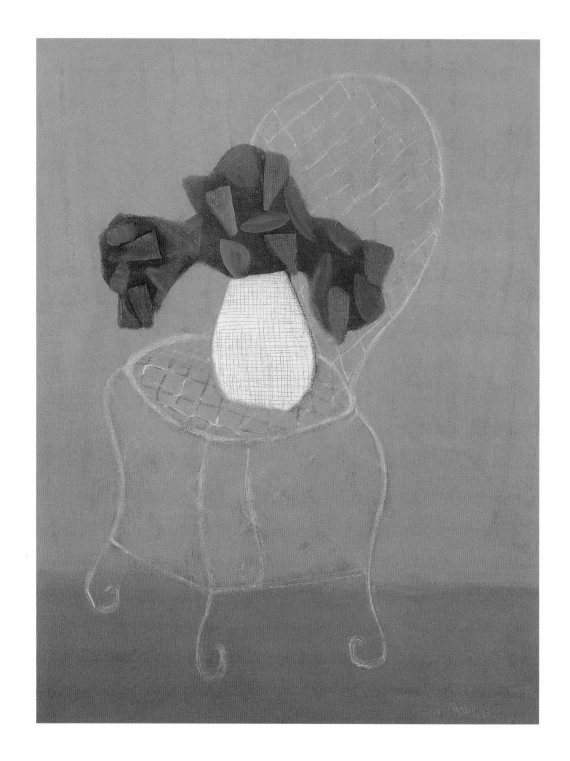

PLATE 10. *CHAIR WITH LILACS*, 1951

PLATE 11. *ORANGE VASE*, 1951

In the post-frontier era, a new view of the nation was needed, and it was in art and literature that the country's new landscape image emerged. In novels and paintings, writers and artists respectively focused on the specific qualities of the typical regions where Americans lived, suggesting that the country could now be seen as the sum of its parts—that it was its varied districts and communities with their particular features and nuances that represented the nation's richness and future. Among the writers were early twentieth-century authors Hamlin Garland, Lewis Mumford, Willa Cather, Lincoln Steffens, and D. H. Lawrence, who described the settled regions where they lived.[47]

Avery sustained this belief in the United States as a country known through its disparate parts. He extended this idea north and south, traveling twice to Canada and once to Mexico. His commitment to the size and diversity of the many regions and communities making up the continent is evident in the paintings he made each summer and autumn, such as *Spring in New Hampshire* (1954; plate 21) and *Bathers by the Sea* (1960). Although he and his family often returned to the same places, over the years they toured a great deal of North America. Avery made visual records of these trips, which served as memory aids for his paintings.

All these works reflect the intimacy Avery had learned from the American Impressionists; we see it in *Hint of Autumn* (1954; plate 24) and *Interlude* (1960; plate 45). This quality of closeness and familiarity may help explain why Impressionism began to seem particularly relevant and timely in the first decade of the Cold War, when fears regarding encroaching communism and possibly nuclear attacks were escalating. Although both Avery's and Impressionism's scenes of domestic life might appear far removed from the Cold War political ideology of containment, they correlate with a sincere need at the time for intimacy and closeness. Instead of accepting the world as detached from human desires and resistant to them, both Avery and the Impressionists downplayed the textures specific to trees, plants, and rocks in favor of painterly qualities that can be manipulated at will. An example of this type of abstraction in Avery's work is his *Chair with Lilacs* (1951; plate 10). Here the world is not threatening; nature is subsumed within a delicate wit. Played like an

instrument, the natural realm oscillates between two and three dimensions. *Sunset* (1952; plate 14), *Bathers by the Sea*, and *Mountain and Meadow* (1960; plate 46) all exhibit this contrapuntal quality. Nature straddles the contradictions of an illusionistic atmosphere manifested through the transparent material medium of paint and a solid, unyielding white canvas surface. This affirmation of art's abstract ability maintains an ongoing instability between subject and technique—between the external world and art's fictive illusions. In its resistance to reality—and, conversely, in its seeming closeness to it—this art appears to respond to the desire of Avery's contemporaries to keep at bay fears regarding the insistent realities of the Cold War and an unknown and perhaps disastrous future.

The home may have been the single most fetishized object in the post–World War II era. It appealed to Americans in the 1950s as one of life's major rewards and an impregnable sanctuary. Avery's painting *Adolescence* (1947; plate 1) presents the home as a closely protected illusion, a place both as actual and as fictive as the scumbled washes of paint that constitute it. Similarly, the natural vistas in many of his works are not the panoramas of mid-nineteenth-century Hudson River School paintings, with their invocations of nature as God's handiwork. Instead, as evidenced by both *Breaking Sea* (1952; plate 16) and *Advancing Sea* (1953; plate 17), they are chimeras: dreams both as real and as removed as imagination permits. Their unreality helps society protect its illusions. And since they are preeminently paintings, their illusory nature is an unassailable fact. This contradiction between illusions and reality was the underlying principle of Avery's landmark exhibition "My Daughter March," which mixed a retrospective of his art with a painted survey of his daughter's life as both artistic construction and biological fact. The exhibition opened in the spring of 1947, one year after Winston Churchill's "Iron Curtain" speech in Fulton, Missouri, gave the term "Cold War" wide currency.

In her provocative study *Homeward Bound*, the cultural historian Elaine Tyler May connects fear of the excesses of the Cold War with a desire for secure homes by viewing them both as manifestations of the concept of containment.[48] This was a political policy of the Cold War years, first defined in 1946 by George F. Kennan, the American *chargé d'affaires* in Moscow.

The name referred to American measures taken to curb the influence of the Soviet Union and China, to restrict knowledge and access to atomic weapons and technology, and to purge society of undesirable subversives with Communist leanings. On the cultural front it became a metaphor for the protective sphere of influence that the home offered the nuclear family, and revealed the family's psychological need for shelter from escalating societal change. May points out that the American family's spending priorities reflected their concerns with security:

Instead of rampant spending for personal luxury items, Americans were likely to spend their money at home. In the five years after World War II, consumer spending increased 60 percent, but the amount spent on household furnishings and appliances rose 240 percent. In the same five years, purchases for food rose only 33 percent, and for clothing a mere 20 percent.[49]

Clearly, the home was regarded as a benign retreat from the stalemate of opposed world powers, the ever-present threat of nuclear holocaust, and the fear of betrayal from within by Communist infiltrators. May suggests that the fears stirred by the Cold War and the urge to reinforce the stability and security of the American home were dramatized by the famous 1959 "Kitchen Debate" between Vice President Richard Nixon and Soviet Premier Nikita Khrushchev, in which each expressed his nation's superiority in terms of domestic innovations. The dispute took place during a tour of a model kitchen at the American National Exhibition in Moscow (fig. 14). May writes: "Americans were well poised to embrace domesticity in the midst of the terrors of the atomic age. A home filled with children would create a feeling of warmth and security against the cold forces of disruption and alienation."

May's argument is in some respects over-simple. But we may speculate that the inability of the United States to reach a détente with the Soviet Union represented such an omnipresent and irresolvable danger for Americans that "the home . . . [became] a source of meaning and security in a world run amok."[50]

To depict the societal dream so that its dominant ideology is exposed and critiqued is no doubt the desire of many thoughtful

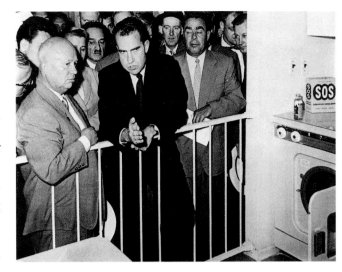

FIG. 14. RICHARD M. NIXON AND NIKITA KHRUSHCHEV DURING THEIR TOUR OF AN AMERICAN EXHIBITION IN MOSCOW, 1959

artists. The trick is to embody this ideology in one's art without being seduced by it and without losing one's critical edge. Yet to try is risky, since an ideology is most effective when it goes underground and is naturalized, seen not as an interpretation of the truth, but as truth itself. More than a mere interpretation or theory, an ideology is an attitude embraced as real by at least one sector of a society. We might hazard the proposition that all aspects of culture are necessarily ideological. If so, we can only escape the encroachments of ideology by avoiding culture itself—an impossible task. Perhaps artists can only hope to be slightly out of sync with their times, so that they may develop images of the world from a slightly skewed perspective. Irony is a useful strategy in this scenario, since it represents a layering of meanings, one almost transparently superimposed over another, so that gaps or fissures in the apparently seamless web of an accepted ideological construct are revealed. In such works as *The Haircut* (1947; plate 6), *Waterfall* (1954; plate 22) and *Plunging Gull*, Avery invokes the ironic mode through tongue-in-cheek, exaggerated forms, flattened perspectives, and artificial color schemes. Viewers seem to be invited to take these images at face value, as charming conceits of three-dimensional reality. Avery begins the game of exposing basic disparities in our perception of the world by establishing an accordion action in his paintings, in which two dimensions assume the appearance of a third. He does this in such paintings as *Sea Grasses and Blue Sea* (1958; plate 38) and *Offshore Island* (1958; plate 34) with loosely

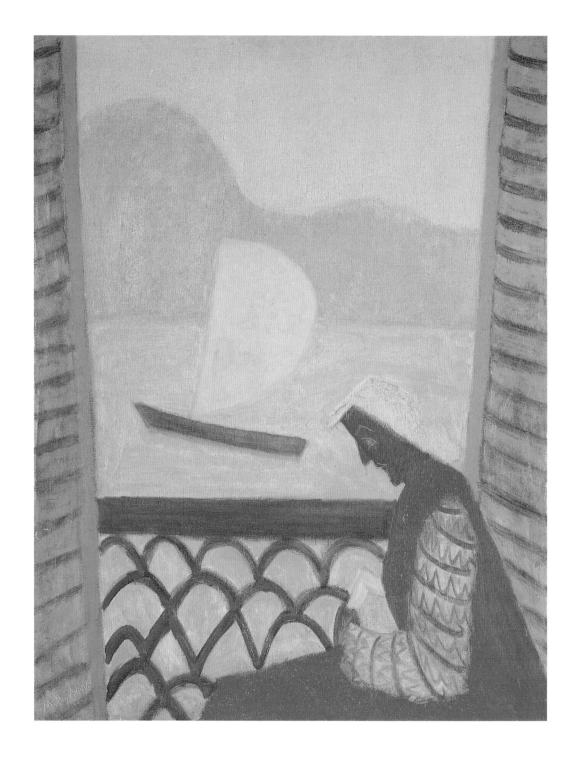

PLATE 12. *MARCH ON THE BALCONY,* 1952

rendered contours and contrapuntal arrangements of hues. The dialectical process of puncturing, with a gentle and gracious wit, the resoluteness of abstract or realistic schemes allows observers to recognize that both art and life are fictions that can be transformed at will.

As we will see, life itself is a series of representations or forms of containment for Avery, and these simulacra, not their real-life equivalents, are what he incorporates in his art. In his paintings the subject of containment is treated with irony. His mid-winter 1947 New York exhibition, "My Daughter March," included a portrait of the artist standing before three completed paintings of his daughter. Holding a brush in his left hand and gazing outside the canvas, Avery's painted surrogate is a mirror image of himself, for he was right-handed.[51] In this way the artist becomes the ideal viewer not only of this particular piece but of the entire exhibition. All prospective observers are linked with his point of view, becoming, figuratively speaking, reflections in the artist's mirror. In this *Self-Portrait* (1947; plate 7) Avery demonstrates the process of transforming his present (and presence) into a painted past, so that he and his viewers—his surrogates—metamorphose into his painted simulacra.

Rather than directly transforming his natural image into an artificial painted construct, however, Avery does so in a three-step process. He begins with a mirror image of himself. Then, tipping his hat to Diego Velázquez's *Las Meninas* (fig. 15), he shows us the back view of the canvas on which he is working. Finally, he naturalizes his style by presenting himself as a painted figure in the act of painting an image of himself. The underlying witty joke is that if the image of Avery being "reflected," mirrorwise, in the painting is the real one, then he is a three-dimensional manifestation of the painting, a cartoon of a figure inscribed in the real world. We are thus left with the conundrum of whether this external viewer sutured into the artist's position is intended to be real or illusory. If it is a painted equivalent, then the process of containment is double-valenced, transforming elements of the real world into artistic equivalents before rendering them in paint. The viewer is called into being as a painted image: life imitates art, while the work of art imitates itself.

The process of abstraction reproduced by *Self-Portrait* reca-

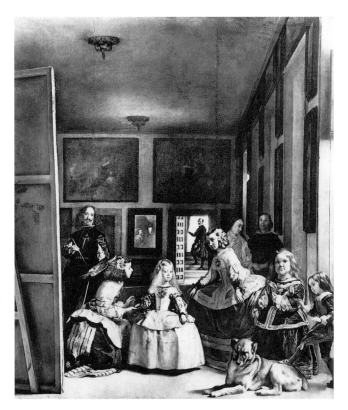

FIG. 15. DIEGO VELÁZQUEZ, *LAS MENINAS*, 1656. OIL ON CANVAS, 125 X 108 INCHES. MUSEO DEL PRADO, MADRID. COURTESY ALINARI/ART RESOURCE, NEW YORK

pitulates a key philosophical issue regarding how representations convey meaning. In Plato's Dialogue the *Cratylus*, Socrates demonstrates that words cannot be mere imitations of things because their primary function as signs distinguishes them from the objects they represent. "The effect produced by the names upon things of which they are the names would be ridiculous, if they were to be entirely like them in every respect," he argues, "for everything would be duplicated, and no one could tell in any case which was the real thing and which the name."[52] Referring to these signs (whether painted representations or language) as "images," Socrates reminds us that a disparity between them and reality is necessary, and the former are the necessary abstractions that enable us to seize hold of the world and manipulate it. We may thus say that Avery begins his paintings with images, not reality, and that his completed paintings are imitations of images and not imitations of things in the world.

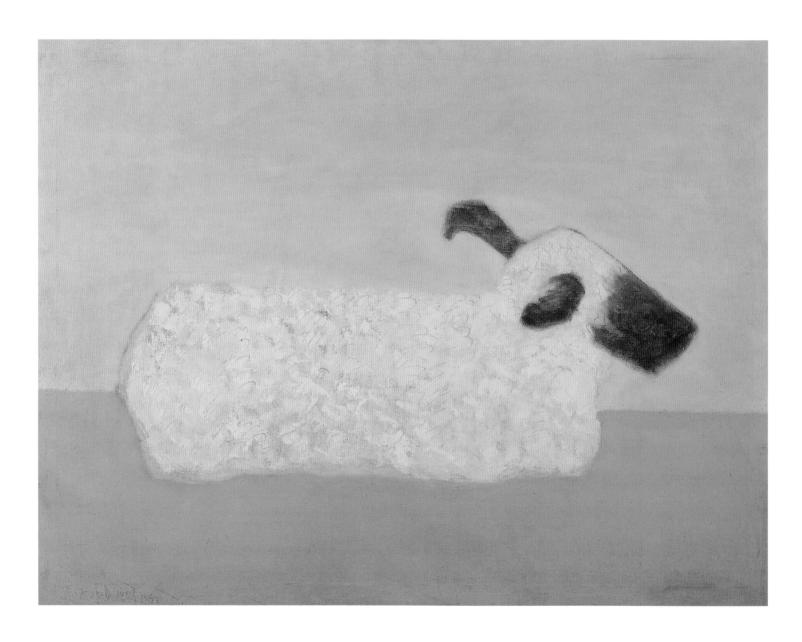

PLATE 13. *SHEEP*, 1952

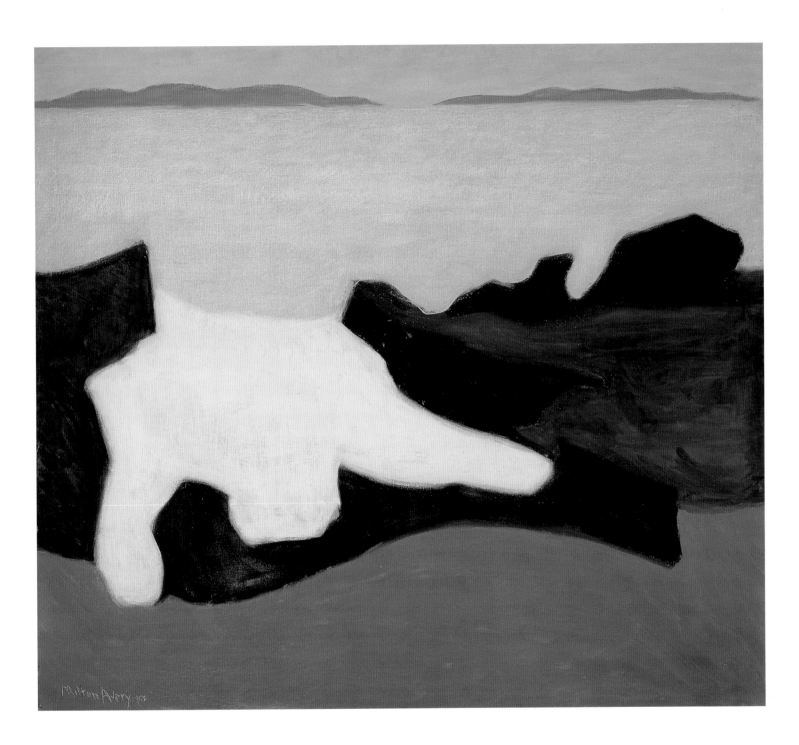

PLATE 14. *SUNSET, 1952*

Early in his career Avery explained this idea obliquely and—rare for this taciturn artist—in detail:

To the so-called conservative art lover, a picture is beautiful if it looks just like the subject, and, of course, the subject must in itself be pretty. Then again if the subject is a poetical landscape, a lively snow scene, or if, in a nude, the model is voluptuous and pretty, this viewer has gotten his thrill and is satisfied that he has seen and knows what is "great art."

With this attitude there is no argument, for it is [as] futile to argue about art as it is about religion. But I cannot help but feel that this attitude is unfortunate.

The so-called modern artist (and I insist that the word "modern" is as confusing and ambiguous as the word "beautiful") looks for plastic values where the conservative seeks representation. That is, the modern looks for design of form, line, color and spatial arrangement, where the conservative looks for "soul," "beautiful expression," and so-called "realism." Personally, I can see as much, if not more, spirituality and soul in a painting of apples by Cézanne as in a Madonna and Child Surrounded by Angels and All the Hosts of Heaven by Murillo for the reasons I have expressed above. If people do not agree with this conception, well and good. All I can say is that they do not get the same experiences out of life and art that I do.[53]

Made only a few years after he moved from Connecticut to New York, this statement represents Avery's early thoughts regarding the relative merits of realism and abstraction. The precision with which he demarcates the boundaries separating imitative and abstract art is significant.

Greenberg, by comparison, hedges on the differences between imitative and abstract art in his essay on Avery. His discussion of Impressionism's contribution of a rigorous eye to modern art is intended to ensure that opticality is accepted without question as a basis for judging quality. But his orientation requires him to judge between acts of perceiving and assimilating works of art, not acts of art making. When he is forced to deal with Avery's generative process of first looking at nature and then transforming his view of it into abstract forms, he finesses the transposition from reality to abstraction:

It is a question rather of the sublime lightness of Avery's hand and of the morality of his eyes; their invincible and exact loyalty to exactly what they alone have experienced. It has to do with exactly how Avery locks his flat, lambent planes together; with the exact dosage of light in his colors. . . . Of course, all successful art brings us up against the mysterious factor of exactness but it operates to an unusual extent in Avery's case.[54]

Greenberg subtly equates Avery's vision with the execution of a work of art, rather than the generation of an idea. In this way he positions Avery to become the ideal viewer of the work, while the generative phase of observing nature and transforming it into a painting is elegantly elided.

In *Self-Portrait* Avery's overall style is consecrated through repicturing already extant paintings of his daughter. As his official painted representative in this exhibition, she is both his metaphorical muse and his metonymic extension. The subject of many paintings, March becomes a genre, like landscape painting (fig. 16). Subsumed within the category of "March" are such works as *The Brown Hat* (1941), seen leaning against the background wall in *Self-Portrait*. In addition to furnishing the artist with the subject for a range of work, March is also his biological reflection, since she is, after all, his daughter. Moreover, since she is left-handed, she functions figuratively as his mirror equivalent. Even more than most of Avery's works, this self-portrait represents the interplay of literal and figurative realms. It is a painting about painting: a representation of the *act* and *condition* of painting; as we have seen, it is also a painting about the self and its surrogates. Furthermore, the images of March within it are copies of reality—that is, of other paintings. *Self-Portrait* comprises a series of highly elaborate, complex, and ultimately ambiguous double and triple distillations of signs and their equivalents. It is also a knowing *mis*representation, since the artist and his daughter, as pictured in it, are conventionalized figures who have been subjected to the dictates of the painting medium even in the pregenerative phase of conceiving them. The painting, this mirrored image, contains a self-enclosed realm of fictions caught up in their own reflections: a world that must be distilled into art before it can enter its cloistered domain.

Avery's landscapes also enact the paradoxical process of

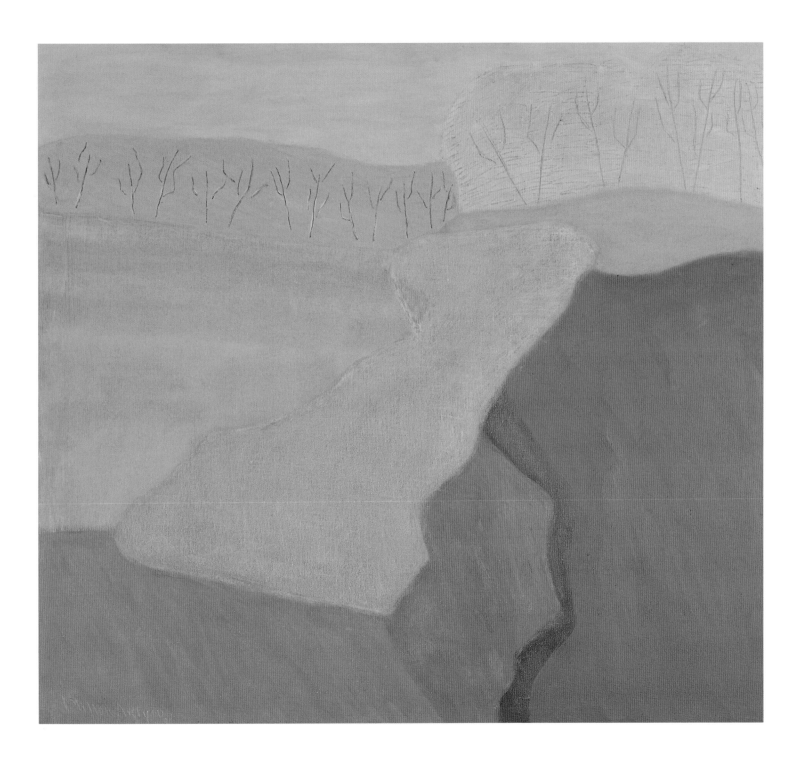

PLATE 15. *SHAPES OF SPRING, 1952*

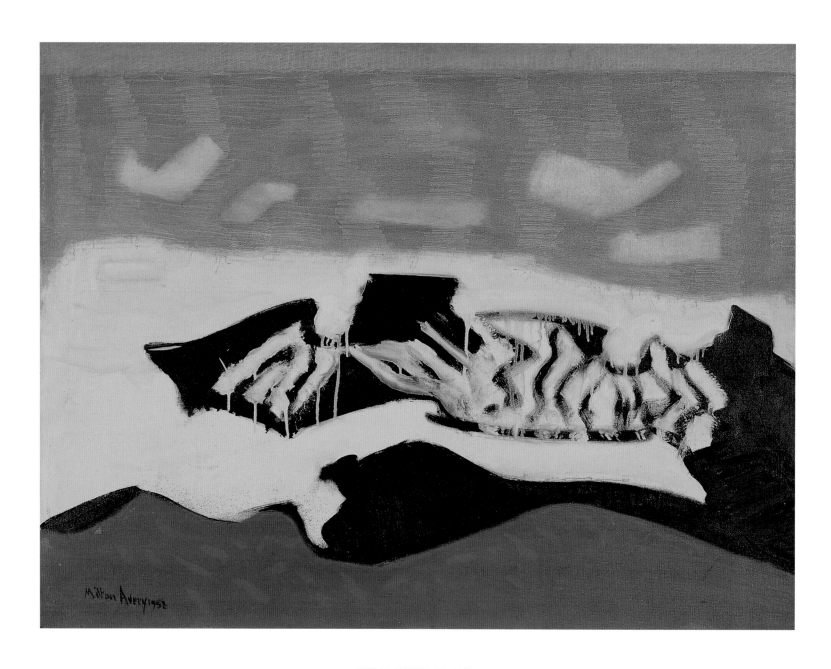

PLATE 16. *BREAKING SEA, 1952*

imaging painting as subject matter while becoming a subject matter to be figured through art. Greenberg regarded the landscapes as his most important works. When Avery looks at nature through the distancing lens of formalism, he is already seeing it in artistic terms in the first, pregenerative phase. Nature becomes cultural in his initial act of looking, as he assesses a view for its artistic potential. This approach echoes, or reinvents, the late-eighteenth-century aesthetic category known as the picturesque. The French painter Claude Lorrain (fig. 17) established the criteria for judging picturesque landscapes. Artists who followed his precedent sometimes went so far as to gaze at natural scenes through tinted lenses called Claudian glasses, which lent them a dark, varnished quality. Avery's landscapes are not Claudian wildernesses, but settled and domesticated scenes in which nature has been reduced to human scale. This intimate, safely circumscribed realm assuages Cold War fears of nuclear holocaust because the painted "natural" views, as presented on canvas, have little in common with the brute force of reality.

Although Avery's intimate views may have placated Cold War–era fears, we should keep in mind that landscapes are always connected with ideology, and nature is always laden with historical values. They may represent the land as a commonly held spiritual value that goes far beyond the purview of private ownership, as Avery's paintings of coasts in *White Sea* (1947; plate 5) and *The White Wave* (1956; plate 27) imply. The literary critic W. J. T. Mitchell suggests that landscape embodies concealed social relations.[55] In times when imperialism has operated with impunity, landscapes have represented the fruit of conquest, or the home base of an empire. In a postcolonial world, representations of the land may function nostalgically, reminding viewers of past aspirations and accomplishments, or keeping the spirit of nationalism and conquest alive. The 1950s were a complex time for the United States, a period when the country was officially both postimperial and still economically and culturally colonizing great portions of Europe through its Marshall Plan, the postwar European Recovery Act that sent aid overseas.

Nostalgia for a remarkable past appears to have played a part in Avery's landscapes and beach scenes, which allude to the literal possession of the land and to the artistic tradition of con-

FIG. 16. THE AVERY FAMILY (MARCH SEATED ON RIGHT), MILLBROOK, NEW YORK, 1949. PHOTOGRAPH WALTER LEWISOHN, COURTESY KNOEDLER AND COMPANY

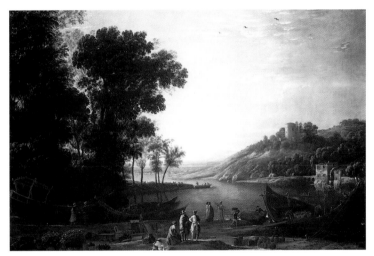

FIG. 17. CLAUDE LORRAIN, *LANDSCAPE WITH MERCHANTS*, CA. 1630.
OIL ON CANVAS, 38¼ X 56½ INCHES. NATIONAL GALLERY OF ART, WASHINGTON, D.C.;
SAMUEL H. KRESS COLLECTION

quering territory. This has been a leading trend in American painting since the early nineteenth century, beginning with the Hudson River School of painting.

This ideological view of the land was of central importance to the Hudson River artists. And when Avery paints New England landscapes, his work captures aspects of that approach.

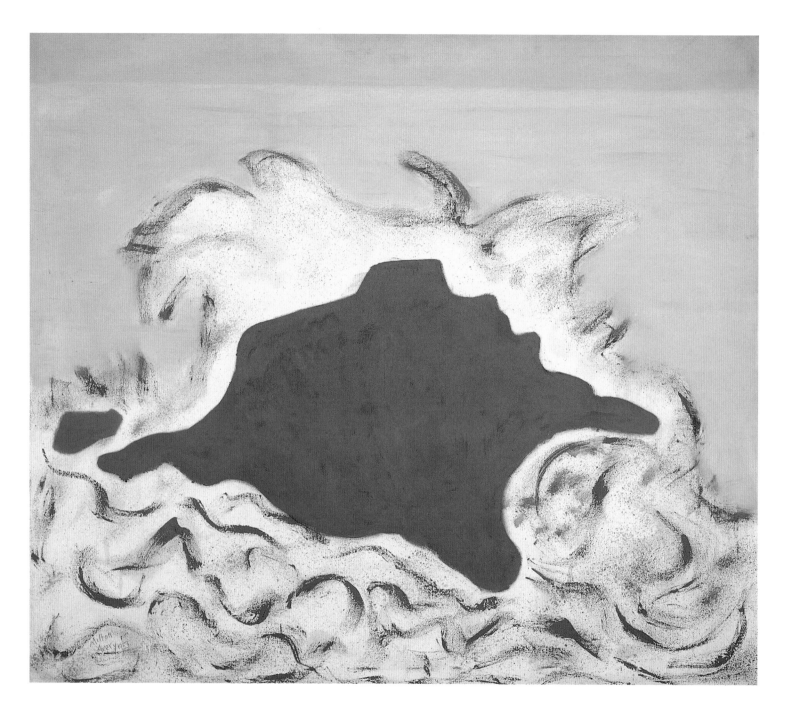

PLATE 17. *ADVANCING SEA*, 1953

Moreover, it represents a fetishized commodity available to those able to take possession of land through vacations or country homes. These paintings are not free of values, but connote material concerns in a spiritualized and indirect form. They suggest the possibility of a transcendence that is accessible to only a few, even though it appears to belong to all. On first looking, this world seems inviolable: people and nature appear to coexist harmoniously and a Golden Age appears to be within reach. But with sustained looking, we see the oscillation back and forth between two and three dimensions in them, which makes them seem more chimerical than actual, thus reinforcing their status as unobtainable dreams. Moreover, Avery's quest for decorative unity in these works is consistent with Clement Greenberg's belief, articulated in the 1950s, that landscape painting will soon be appreciated only for its formal qualities.

This art appears to exemplify an idealist, bourgeois culture that has lost its original revolutionary character. Bourgeois art sets itself above the inequitable conditions of social life and masks them, thereby endorsing the *status quo*. But Avery's work problematizes the middle-class dream by making it fluctuate uneasily between apparent reality and a heightened artificiality. His landscapes and figurative paintings wryly reflect bourgeois culture as a wavering and distant fantasy. This art does not ratify, but critiques culture; its success can be gauged in how well it mirrors to society the unreality of its dreams. The success of such paintings depends in part on their ability to beguile and seduce affluent viewers into savoring the very qualities that undermine them.

Formalism has often been called universal, but is in fact ideological. Avery uses formalism as a means of seizing hold of already mediated aspects of life, thus keeping at bay fears regarding the unmanageable and chaotic postwar world. His art represents a doubling and refolding of the idea of containment. First, his images invoke the strength of the United States and its past as a safe refuge. Second, his formalism subsumes aspects of past and present within the rubric of modernism, which in his hands is a period style. And third, in spite of a high degree of abstraction, expressed in flat passages of color, he inserts an incipient third dimension into his works. In *Dunes and Sea I* (1958; plate 37), for example, a subtle space is created through the dynamics

of warm and cool colors separated by softly brushed purfles. Ever-so-slight oscillations occur along these ruffled edges, cracking the thin veneer of abstracted and domesticated landscape. A natural and not entirely mediated world begins to insinuate itself into these interstices. The landscape that peers through the veneer of the abstract is not real, however. Instead, these breaks establish a dialectical way of looking. Both realism and abstraction are revealed as playful, delightful constructs that mime the ideological constraints of the so-called actual world. Greenberg describes this technique: "Nature is flattened and aerated in Avery's landscapes, but not deprived in the end of its substantiality—which is restored to it as it were by the substantiality and solidity of the picture itself as a work of art. The painting floats, but it also coheres and stays in place, as tight as a drum and as open as light."[56]

When Greenberg selected Avery as the standard bearer for the next generation, he was well aware of the painter's conservative position vis-à-vis Abstract Expressionism. Rather than trying to mold Avery into a prototypical avant-garde revolutionary, however, the critic used him to declare that rearguard art was assuming a new role in relationship to the vanguard. His choice of Avery indirectly refers to a group of young artists who were questioning the imperatives of the avant garde.

Like Greenberg, Elaine de Kooning also questioned the cliché that equated the rearguard with representational art and the avant garde with abstraction. In "Subject: What, How or Who?" she writes as both critic and figurative artist, describing the frustrations of contending with the art world in the mid-twentieth century:

Revolution means existence, not progress, for the artist. But you cannot knock over a structure that has already been blown to pieces. In a period like the present, eclectic to the point of chaos, there is no way to contradict, because each revolution is immediately swallowed by a convention. Every new style is accepted without question by the artist and the audience of the avant-garde. . . . There is, however, still a prevalent belief that abstract art is, per se, revolutionary; that representational art is, per se, reactionary. . . . Shocks today are mock-shocks. The opponents are all straw men. . . . Docile art students can take up Non-Objective art in as

conventional a spirit as their predecessors turned to Realism. The 'taste bureaucracy'—museums, schools, art and architecture as well as design and fashion magazines, advertising agencies—all freely accept abstraction, if largely on a false premise, as a matter of style, not of subject.[57]

In pointing to the erasure of essential differences between abstraction and realism, she is careful to characterize nature as encompassing culture: "Nature might be defined as anything which presents itself as fact—that includes all art other than one's own."[58] De Kooning's critique suggests that the vanguard's oppositional force has been diminished. A new apathy reigns, and traditional tensions between old and new, conservative and radical have relaxed. The world has been so interpreted (a decade later it would be termed "mediated") that differences between art and reality are blurred. This generation deemphasized originality and embraced tradition, as it reevaluated the excesses of vanguardism:

Western art is built on the biographical passion of one artist for another. . . . That something new in art cannot come into existence despite influence is a ridiculous idea, and it goes hand in hand with an even more ridiculous idea: namely, that something totally new, not subject to any influence can be created.[59]

De Kooning suggests that the work of artists who continue to value originality is beginning to look predictable and even shopworn.

The reformulation of the role of tradition was an important component of the second-generation New York School. It took a surprising form in a brief 1961 essay by Fairfield Porter, himself a conservative painter of figurative plein-air scenes. Instead of considering tradition a convention that the vanguard can dispense with at will, Porter regards it as essential to any culture. "Traditionality is on the side of civilization," he reminds the reader.[60] He claims the Abstract Expressionist painter Robert Motherwell as a traditionalist (fig. 18). Motherwell's seeming nonconformism exemplifies vanguard conformism: "Motherwell believes in the formality of his own time, which is called informality. He completely accepts his era. Even his belief in

novelty (which he has stated) is conservative. His is the conservatism of the soft shirt, the open collar, the modern chair—a decorous liberalism. . . . His acceptance of his era is so uncritical as to be liberating. . . . Motherwell is of his time and very much in it."[61]

Porter and de Kooning both question the modernist equation of vanguard abstraction with progress, criticality, and political radicalism. Their perspective is crucial to any discussion of Avery's painting, and of Greenberg's interpretation of it. Through them we see that in the mid-1950s advanced artistic thought is no longer the special preserve of abstraction, and that Avery and Greenberg were aware of this. The two essays were written within a seven-year time period, a special time in the history of American art, when the critical force of modernist abstraction had been partially undermined. Rearguard figurative art and vanguard abstraction were beginning to exchange places, so that the clear genealogies of modernism outlined when MoMA was new now appeared dated (fig. 19).[62] Greenberg did not give up his conviction that modernist abstract painting represented the highest qualitative aspirations of his time, but he did temper his outlook. His search for a calmer art, generated through thin washes of luminous color, rather than predicated on the austere rigors of Cubist form, is a clear indication of this change.

Greenberg's shift from Pollock to Avery may be indebted to the ideology of the team player, which was replacing that old American prototype, the rugged individualist. This change, reflected in the appearance of a new postwar managerial class, was first clearly articulated in David Riesman's important sociological treatise *The Lonely Crowd*, subtitled "A Study of the Changing American Character."[63] Riesman's study proposes that the old American "inner-directed" individual is being supplanted by the "other-directed man." This new type was a corporate representative of the booming postwar American economy that had arisen from the conversion of vast war production into peacetime factories capable of meeting escalating consumer needs. The other-directed man was the prototypical salaried, middle-class bureaucrat, working for big business. He had moved from traditional urban neighborhoods to the new suburbia and relied on conformism, traditional values, and

FIG. 18. ROBERT MOTHERWELL, *N.R.F. COLLAGE, NUMBER 2*, 1960. OIL AND COLLAGE
ON PAPER, 28⅛ X 21½ INCHES. WHITNEY MUSEUM OF AMERICAN ART; PURCHASE,
WITH FUNDS FROM THE FRIENDS OF THE WHITNEY MUSEUM OF AMERICAN ART.
PHOTOGRAPH GEOFFREY CLEMENTS

general affability as stabilizing forces. Such shibboleths as team spirit, groupthink, and togetherness were frequently used to refer to this figure.

The modernization of Impressionism, the role reversal of the rearguard and vanguard, and the dominance of the other-directed individual all roughly parallel a peak period of American prosperity, the decade from 1954 to 1964. In these years the working person had more discretionary income than before or after. Roughly two generations of Americans who had been restricted by the general deprivations of the Great Depression and World War II were at last able to indulge themselves in an unending buying spree, acquiring new homes, contemporary furniture, and the latest models of appliances and cars. The emphasis on the new that can be charted through their purchases was part of the vast machinery created to grease the wheels of the economy. The ideological ratification of the new included programming taste, designing new objects with planned obsolescence, and extending the power of the mass media. The focus was on the ever-growing (and largely constructed) needs of the nuclear family, isolated in the new suburbs.

So extensive in the 1950s was the emphasis on consumption and the subversion of traditional values through increasing materialism that in art the accent on innovation—the former rallying cry of so many twentieth-century vanguards—began to seem suspect, if not morally bankrupt. Some younger painters began to look at the postwar world with extreme irony. Larry Rivers painted *Washington Crossing the Delaware* (fig. 20) and Grace Hartigan produced *Grand Street Brides* (fig. 21). John Chamberlain, Richard Stankiewicz, and others made sculptures from the refuse of American society. Still others, such as Joan Mitchell (fig. 22) and Philip Guston, used aspects of Monet's formal innovations to arrive at the quasirealist style Abstract Impressionism, which problematized the clear separation of the past from the present. Although a member of an older generation, Milton Avery may be located on the margins of this last group, and his art seen as participating in the reversal of values between rearguard abstraction and vanguard figuration. Greenberg hints at this: "Avery's attitude is the opposite of what is supposed to be the common American one toward nature: he approaches it as a subject rather than object; and one does not manipulate or transform a subject: one *meets* it." And a few lines later he states, "What is specifically American, I feel, in Avery's case is his employment of abstract means for ends that, however subtly naturalistic, are nevertheless intensely so."[64] It is interesting to note Greenberg's equivocation here. His statement leaves us in doubt—as he may well have intended—as to whether the adverbial expression "intensely so" refers to Avery's abstraction or his naturalism.

Only after establishing Avery's American qualities is Greenberg comfortable settling the subject of his debt to French Fauvism. Even at this juncture in his discussion he is careful to couch the transplantation of this style to the United States in

The following labels appear within the diagram:

1890 — JAPANESE PRINTS — Gauguin d. 1903 — Cézanne Provence d. 1906 — SYNTHETISM — Seurat d.1891 d. 1906 — NEO-IMPRESSIONISM — 1890

Van Gogh d. 1890 — 1888 Pont-Aven, Paris — 1886 Paris

1895 — Redon Paris d. 1916 — Rousseau Paris d. 1910 — 1895

1900 — 1900

NEAR-EASTERN ART

1905 — FAUVISM 1905 Paris — NEGRO SCULPTURE — CUBISM 1906-08 Paris — 1905

1910 — (ABSTRACT) EXPRESSIONISM 1911 Munich — FUTURISM 1910 Milan — MACHINE ESTHETIC — ORPHISM 1912 Paris — SUPREMATISM 1913 Moscow — 1910

1915 — Brancusi Paris — CONSTRUCTIVISM 1914 Moscow — 1915

(ABSTRACT) DADAISM Zurich Paris 1916 Cologne Berlin — PURISM 1918 Paris — DE STIJL and NEOPLASTICISM Leyden 1916 Berlin Paris

1920 — 1920

BAUHAUS Weimar Dessau 1919 1925

1925 — (ABSTRACT) SURREALISM 1924 Paris — MODERN ARCHITECTURE — 1925

1930 — 1930

1935 — NON-GEOMETRICAL ABSTRACT ART — GEOMETRICAL ABSTRACT ART — 1935

FIG. 19. JACKET OF ALFRED H. BARR, JR.'S *CUBISM AND ABSTRACT ART*, 1936.

THE MUSEUM OF MODERN ART, NEW YORK

nationalistic terms. He compares Fauvist work with the art of Avery, Arthur Dove, Arnold Friedman, Hartley, and John Marin (fig. 23):

But while the original Fauves, in France, would, where they could, sacrifice the facts of nature to an inspired decorative effect, the Americans tended to let the decorative effect go when it threatened to depart too much from the facts. For it was in the facts primarily that they found their inspiration, and when they didn't find it there they would fall into artiness.[65]

According to Greenberg's analysis, American pragmatism is preserved in the art of this stalwart group of five, who have withstood the temptations of Parisian fashion, even though Avery almost succumbed to its artifice. "All this applies to Avery, and to him especially," he asserts.[66] Greenberg is especially eager to clear Avery of the charge of French decadence, since he had often been called the quintessential "American Fauve," beginning in the 1940s.

Avery's work has been closely aligned with Fauvism in general and Matisse's work in particular. These real and perceived correspondences must now be placed in proper perspective. Greenberg wrangled with this problem. He noted that if in the 1940s he "failed to discern how much there was in these [works of Avery's] that was not Matisse at all, it was not only because of my own unperceptiveness, but also because . . . the artist himself contrived not to call enough attention to that which was his and no one else's."[67] He then named a number of other stylistic sources for Avery, including Raoul Dufy, Hartley, and Marin.

We might approach this difficult problem by discerning historical reasons for the alignment of Avery with Matisse. One of the earliest references linking the two artists is an anonymous 1938 review of a show at Valentine Gallery in New York that compares them in order to question Avery's originality: "Unlike Matisse, the genius of the movement, Avery's colors are rarely pure and singing, but are instead muted in harmony with the spirit of travesties." Rather than finding this change innovative, this writer remarks that Avery "arbitrarily manipulates, for the sake of both design and expression, the laws of natural color, of perspective and classic form."[68] The reviewer condemns Avery for making the external world conform to the dictates of his art, but does not notice that Matisse's reputation was predicated on similar licenses with perspective and form. The comparison is strictly formalist, but the pairing of the names may not have been fortuitous, since Valentine Gallery had held a notable retrospective of Matisse's work in 1927.

Owned by Valentine Dudensing, this gallery was known for showing Americans such as Louis Eilshemius, John Kane, John Koch, Raphael Soyer, and Joseph Stella, but its European connections were still intact in the mid-1930s, when Avery began exhibiting there. Soon after he did so, the prominent collector Alfred C. Barnes, who had commissioned Matisse to paint a large mural for him, purchased a beach scene by Avery that he had seen there. Avery's lifelong friend Wallace Putnam later attributed the interest that the gallerist Paul Rosenberg showed in Avery's art to this sale.[69] But Paul Rosenberg & Company—a French firm with offices in London, Paris, and New York City that handled the Americans Marsden Hartley, Max Weber, and Abraham Rattner in addition to Matisse and Pablo Picasso—

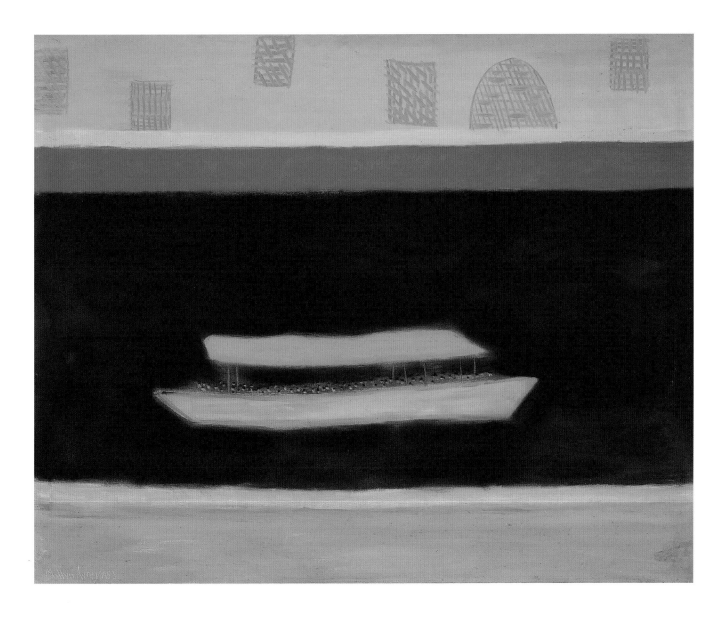

PLATE 18. *EXCURSION ON THE THAMES*, 1953

asked Avery to show there fully eight years after this important sale. In the interim Valentine Gallery maintained a firm hold on Avery's allegiance by featuring him in four additional solo exhibitions and one two-person show.

Even with this support, Avery's career languished, perhaps because critics had not yet clearly distinguished its goals and accomplishments. When he joined the Rosenberg gallery in 1943, his career received an enormous boost. During that first year his paintings were featured in a solo exhibition in the summer, and his watercolors were promoted in a one-person exhibition in the fall.

Rosamund Frost heralded this change of venue in a cru-

FIG. 20. LARRY RIVERS, *WASHINGTON CROSSING THE DELAWARE*, 1953.

OIL ON CANVAS, 83⅝ X 111 ⅜ INCHES. THE MUSEUM OF MODERN ART;

GIVEN ANONYMOUSLY

FIG. 21. GRACE HARTIGAN, *GRAND STREET BRIDES*, 1954.

OIL ON CANVAS, 72 X 102½ INCHES. WHITNEY MUSEUM OF AMERICAN ART;

GIFT OF AN ANONYMOUS DONOR (55.27). PHOTOGRAPH GEOFFREY CLEMENTS

cially important essay, "Milton Avery, American Fauve," that appeared in the December 1942 issue of *Art News*. This inaugurated a paradigm shift in the critical reception of the artist's work. The critics, she says, have misunderstood Avery as an American Scene painter *manqué*: "We have . . . caught up with Milton Avery, our most native and genuine American Fauve. . . . Unlike

the Cubists, his dynamics take place on the flat surface of the canvas. . . . But color is the real soul of his painting, color as finely balanced (though more varied) as Braque's and often as inventive and unorthodox as Matisse himself."[70]

The following year a number of prominent critics corroborated Frost's assessment. Maude Riley pointed out in an *Art Digest* review:

Emily Genauer of the World-Telegram *calls the simple, unpretentious Avery manner 'sophisticated in the sense that Matisse and Bonnard are sophisticated' in the 'knowing distortion of shape, juxtaposition of ordinarily unsympathetic colors, patterning of surface.' [Edward Alden] Jewell, too, sensed the Matisse influence when he stated that 'the genesis of Milton Avery's style is Fauve.'*[71]

At this point Avery's reputation as the quintessential Fauve seems to have been proposed and immediately accepted. That same year buyers also recognized his seriousness and originality. His work began to attract a number of collectors, and for the first time in his career he began to sell his work on a regular basis.[72]

Paul Rosenberg faced serious competition over the next several years. The oldest French firm in New York, the illustrious Durand-Ruel Galleries, took an interest in Avery, and the Phillips Memorial Gallery in Washington, D.C. (now the Phillips Collection), with its important collection of European modern art, initiated 1944 with a January showing of his watercolors.[73] The next month Rosenberg exhibited his recent paintings, and Durand-Ruel followed with a show in April. The next year the two firms joined forces to give Avery simultaneous exhibitions: On January 8 Rosenberg & Company opened an exhibition of Avery's recent gouaches of Connecticut landscapes and Massachusetts beach scenes; the following evening Durand-Ruel Galleries commenced its exhibition of oil paintings depicting these same locales. In 1946, the two galleries switched places, with Rosenberg giving place of honor to paintings and Durand-Ruel featuring watercolors.

The popularity of Avery's work depended on the association of him with American Fauvism, which in turn was linked in the public mind with the war effort, particularly the European

FIG. 22. JOAN MITCHELL, *GEORGE WENT SWIMMING AT BARNES HOLE, BUT IT GOT TOO COLD*, 1957. OIL ON CANVAS, 85¼ X 78¼ INCHES. ALBRIGHT-KNOX ART GALLERY; GIFT OF SEYMOUR H. KNOX, 1958 (K1958:11)

FIG. 23. JOHN MARIN, *TREE FORMS, MAINE*, 1915. 19⅛ X 16⅛ INCHES. THE METROPOLITAN MUSEUM OF ART; ALFRED STIEGLITZ COLLECTION, 1949 (49.70.113)

theater of operations, and anxiety about the fate of Paris. Still regarded as the center of world culture during the war, German-occupied Paris had served as a rallying point for the Allies. Avery, the American artist most clearly perceived as aligned with French sensibilities, found himself in great demand by the war's end. The German occupation of France made the export of works by French masters extremely difficult, and perhaps Avery's work was sought after because it helped to fill this gap. This argument, however, is difficult to sustain, since many European expatriate artists had already moved to the United States because of the war, and the market for French art was being met in a variety of ways. We must conclude instead that Avery's Fauve designation put him in sync with the American wartime identity, since the country's outlook had become European-oriented.[74] The fascination with Avery's work at this time is indicative of a deeper desire to affiliate the United States with Europe, and particularly France. The combined campaign undertaken by Paul Rosenberg & Company and Durand-Ruel Galleries to promote Avery to master status recognized that a new ideological forma-

tion had occurred in the United States in the early 1940s.[75] Almost overnight, with its entry into the war, the country transformed itself from an isolationist outpost into an international power directly implicated in world affairs. Avery's American Fauve designation represented this new status with a sleight-of-hand charm and an understated wit that seemed disarmingly French, while his subject matter remained firmly rooted in the comfortable traditional American themes of hearth, home, and landscape.

Paintings that he made after a trip to France in 1952 reflect a brief moment of nostalgia for the war years, when he had been lauded as the American Fauve. From this excursion a number of important paintings were created, including *The Seine* (1953; plate 19). They belong to a time when the United States was celebrating French culture. Widespread homage to France may be seen in the revisionist views of Impressionism that we have already discussed, in the popularity of French fashions such as

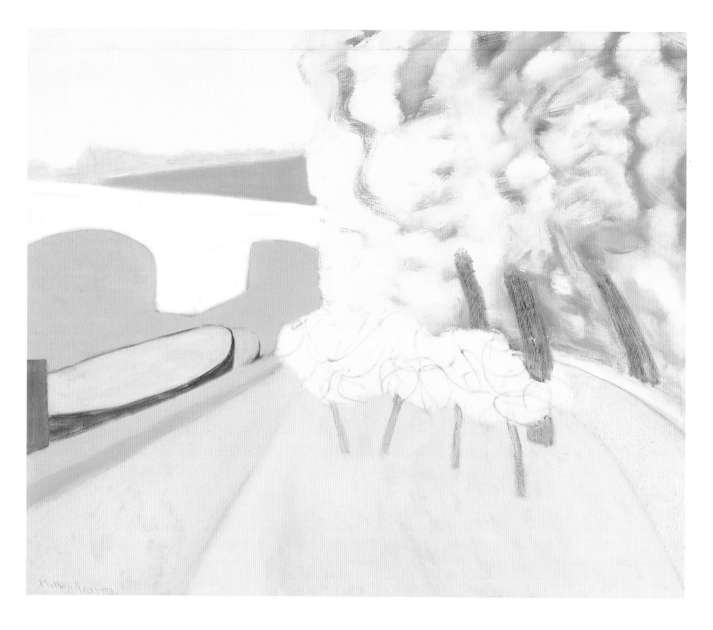

Christian Dior's New Look, and in such popular postwar films as *An American in Paris* (1951) and *Moulin Rouge* (1952).

Only by taking into consideration the wartime reappraisal of Avery's importance can we hope to unravel later arguments regarding his French and American affiliations. The war cemented the United States's relationship with France and encouraged an internationalist hybridity in American culture; this extended to the immediate postwar period, after which the United States felt a need once again to commemorate its distinctiveness. At this point Avery's critics began trying to separate his work from Matisse's. In a review of his 1960 retrospective at the Whitney Museum of American Art, Barbara Guest under-

scored Avery's independence from Matisse and affirmed his intractable, undeniable, pure American spirit:

In neither artist [Avery and Lee Gatch] do there appear the elements of the European tradition. True, Avery has been likened to Matisse with his thin paint surface, the dominance of color in his paintings, the slight Matisse-like distortion of his figures. But this comparison is one of the quick, relating look. It does not take into account an entirely different attitude toward art. Matisse subjugated the past, the tradition of art, and turned its ends to his means. For Avery there is the Yankee disinheritance. His paintings have no past and they have only the present which he chooses to bring to them.[76]

Perhaps no one has argued so strongly for the artist's individuality as his widow Sally Michel Avery.[77] In a series of extended interviews with Louis Schaeffer for Columbia University's Oral History Research Office, conducted in 1978 and 1980, Michel asserted her husband's singularity. When questioned about the rubric "American Fauve," she responded:

Well, I think that's a misnomer. His color was brilliant but he never had that kind of frenetic quality that the Fauves have. He always had . . . a very ordered sense about the way that he used color. He was never a Fauve in the sense that Derain, and even Matisse, was at that time.[78]

Eight years earlier, Michel had observed that "Matisse was a hedonist. Milton was a puritanical man of very simple tastes."[79] She repeated this judgment almost word for word in one of her interviews with Schaeffer and then elaborated on Avery's differences from Matisse: "His things are much more philosophic than Matisse's. . . . They're very sort of New England, sparse New England things."[80] Just as the term "American Fauve" accorded with national policy during the war years, so too the designation "New Englander" responds to a postwar taste for things American. While neither is wholly true, neither is entirely false; both should be used to diagnose the temper of the times, rather than to explain any inherent qualities in Avery's art.

Avery himself was a product of his times and was as suscep-

FIG. 24. MILTON AND SALLY AVERY, WOODSTOCK, NEW YORK, 1950.
PHOTOGRAPH LEE SIEVAN, COURTESY KNOEDLER AND COMPANY

tible as his wife to the ideological forces at work in mainstream culture. In the postwar era he is reported to have complained, "Some critics like to pin Matisse on me. . . . But I don't think he has influenced my work."[81] While this statement may not be valid, we do not have to derogate it as disingenuous or self-serving. It references not so much the artist's overall response to Matisse as the particular time and circumstances in which he made it, as well as the accepted social construction of the artist in the increasingly nationalistic post–World War II period. The cogency of Bourdieu's theory of the artistic field rests primarily on its ability to encourage a contextual consideration of statements, rather than accepting them at face value. Bourdieu's notion of a field of cultural production encourages us to consider individual statements as implicit expressions of their present circumstances, rather than explicit statements of independent fact. It enables us to look for connections between Avery's and Matisse's styles, since these connections were regarded as pertinent in the 1940s and as late as Avery's 1952 trip to France. On his return he painted *March on the Balcony* (1952; plate 12), which courts comparison with Matisse's famous *Open Window, Collioure* (fig. 25). But this type of field analysis reminds us also that Avery so internalized the lessons of Matisse that specific examples of his Fauvism were no longer necessary models.

While Avery's later estimation of Matisse's significance depends on the specific time and circumstances in which it was articulated, we can understand his earlier connection with Matisse by looking back to 1931, when the latter's ideas were first

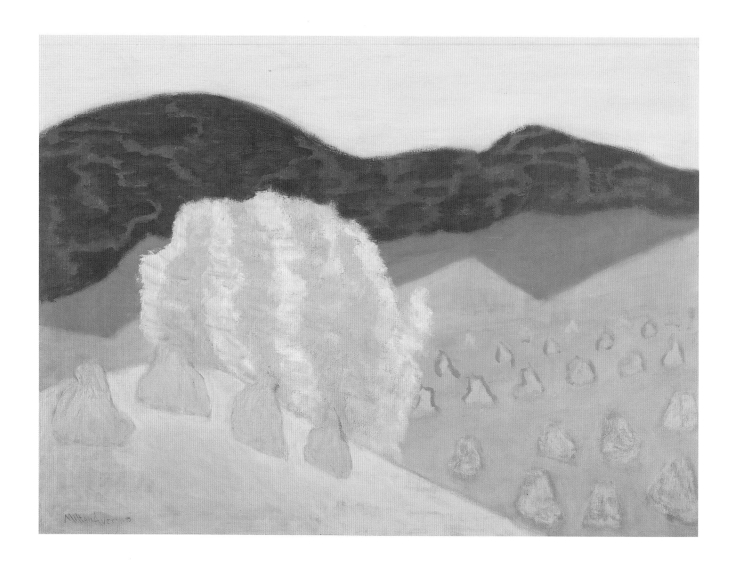

PLATE 20. *HARVEST*, 1953

published in English in a cogent and structured form. The occasion was Matisse's first retrospective at MoMA. The catalogue for this exhibition published notes by Sarah Stein, a student at the Académie Matisse in Paris, in 1908. They were republished in the 1951 MoMA retrospective catalogue of Matisse's art.[82] Avery no doubt knew this text, in which we can easily discern a number of ideas that were significant for him.

Speaking in the most pragmatic terms possible, Matisse compares painting to carpentry. "Fit your parts into one anoth-

er," he advises his students, "and build up your figures as a carpenter does a house. Everything must be constructed—built up of parts that make a unit: a tree like a human body, a human body like a cathedral."[83] As we have seen in our discussion of Ryder, the mature Avery is accustomed to composing his works with simple, flat, interlocking shapes. Whether he initially learned this concept from Ryder or from Matisse is a moot point, since both structured their works thus. It may have been one reason why his late works tended to be simpler and even more inte-

grated than his earlier ones, so that the marginal areas of one form become the borders of the next. However, in spite of their resoluteness, Avery's interlocking shapes in his figure paintings did not satisfy Greenberg, who criticized his models for "not [being] locked securely in place against the blank background" and for allowing "the silhouette[s] of his figures . . . to break through . . . [and] create an effect of patchwork,"[84] even though Avery had moved further in this direction in his late figure paintings than Matisse had.

Avery referred obliquely to this idea of interlocking and simplifying forms in 1931: "If I have left out the bridles or any other detail that is supposed to go with the horses, trees, or the human figure, the only reason for the omissions is that not only are these details unnecessary to the design, but their insertion would disorganize space in the canvas already filled in by some color or line."[85]

The year after the 1951 Matisse exhibition, Avery addresses this same concept from a different perspective: "I do not use linear perspective, but achieve depth by color—the function of one color with another. I strip the design to essentials; the facts do not interest me as much as the essence of nature."[86] The nature to which he refers is twofold: it is both the external world, the subject of his art, and the reality of the work itself, its abstract components.

Not once but twice in Stein's notes Matisse cautions his students to make full use of their imaginative faculties by envisioning their compositions beforehand:

To one's work one must bring knowledge, much contemplation of the model or other subject, and the imagination to enrich what one sees. Close your eyes and hold the vision, and then do the work with your own sensibility. . . . Close your eyes and visualize the picture; then go to work, always keeping these characteristics the important features of the picture. And you must at once indicate all that you would have in the complete work. All must be considered in interrelation during the process—nothing can be added.[87]

These instructions parallel Avery's straightforward assessment: "Today I design a canvas very carefully before I begin to paint it."[88] As his wife pointed out on numerous occasions, and as crit-

ics have for years confirmed, this design was not an imprimatura sketched on the canvas as a guide to creating a painting; it was a design conceived as completely as possible in the artist's mind. Since Avery painted directly, so that his work would be as fresh as possible, he required a process that would enable him to work quickly, and previsualization became his preferred mode.

Although the Fauves were accused of taking enormous license with nature, Matisse explained to his students that they should remain respectful of the motif and should only allow themselves to transform it if the changes reinforced their initial concept. He warned against exaggerations and whimsical gestures that glorify an artist's subjectivities at the expense of the motif:

I do not say that you should not exaggerate, but I do say that your exaggeration should be in accordance with the character of the model—not a meaningless exaggeration which only carries you away from the particular expression that you are seeking to establish. . . . Therefore exaggerate according to the definite character for expression.[89]

This clear, cogent reasoning testifies to Matisse's early training in law, particularly his practical ability to judge exactly which elements will compose a successful picture. If we substitute the phrase "abstract idea" for "particular expression" in Matisse's statement, we can see how much Avery's thought chimes with it. In 1931, the year Avery first had an opportunity to read Matisse's theories in depth, he established some similar guidelines for his art:

Mr. Avery believes that paintings must not be "literary"; but rather, they should express a more or less abstract idea, largely of an aesthetic nature. To get this effect, he said, the canvas must be completely organized through the perfect arrangement of form, line, color and space. Objects in the subject matter, therefore, cannot be painted representatively, but they must take their place in the whole design. This means, he said, that sometimes the figures must be larger than they are in real life and sometimes smaller, for they are useful only insofar as they blend into the general arrangement of the design. The same rule applies to color and light. To those who do not see the aim of the artist, the effect seems to be

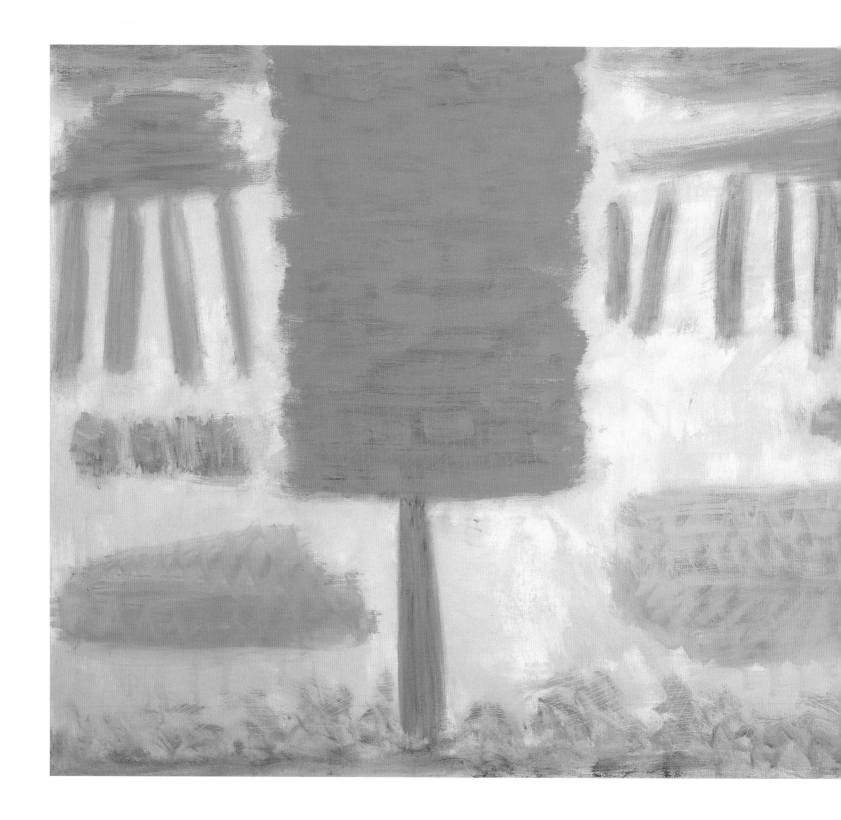

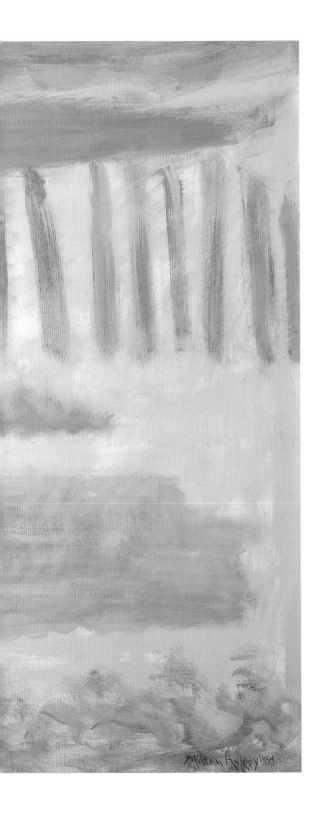

distortion, Mr. Avery declared, but to the painter it is simply the result of a planned organization of all the elements that enter into the space of the canvas. El Greco elongated his figures for the same reason, Mr. Avery said.[90]

The rule for both Avery and Matisse is clearly enunciated: abstraction is valid only if it supports the artist's original idea; distortion for effect is mannered and therefore unwarranted.

As an adjunct to his dictum regarding exaggeration, Matisse builds a case for simplified schema. He stresses the power of contrapuntal compositions predicated on mutually resisting forces. He states, "The mechanics of construction is the establishment of the oppositions which create the equilibrium of the directions." He reminds his students that in decadent periods this concept was reduced to an opposition of niggling details. But "in all great periods the essentials of form, the big masses and their relations, occupied [the artist] above all other considerations—as in the antique."[91] Avery's thinking along these lines takes the form of the following observation:

I like to seize the one sharp instant in Nature, to imprison it by means of ordered shapes and space relationships. To this end I eliminate and simplify, leaving apparently nothing but color and pattern. I am not seeking pure abstraction; rather, the purity and essence of the idea—expressed in its simplest form.[92]

In addition to conceiving his compositions in terms of large simple masses, Avery considers them to be involved in a dialectic between the requirements of abstract composition and his initial concept. "I work on two levels," he reported. "I try to construct a picture in which shapes, spaces, and colors form a set of unique relationships, independent of any subject matter. At the same time I try to capture and translate the excitement and emotion aroused in me by the impact with the original idea."[93] Although the idea may be catalyzed by nature, it replaces exter-

PLATE 21. *SPRING IN NEW HAMPSHIRE*, 1954

nal reality to become the raison d'être for the work. This idea accords with one of Matisse's sayings, included in Stein's notes, in which he reminds his students, "You are representing the model, or any other subject, not copying it; and there can be no color relations between it and your picture; it is the relation between the colors in your picture which are the equivalent of the relation between the colors in your model that must be considered."

He points out that mimesis counts for little in art. Instead, an artist "must render the emotion [the objects in the world] awaken in him." Matisse is convinced that the resultant work of art depends on "the emotion of the ensemble, the interrelation of the objects, the specific character of every object—modified by its relation to the others—all interlaced like a cord or serpent."[94] The concept is a Symbolist one that has its origins in the research of the French poets Arthur Rimbaud and Stéphane Mallarmé, among others, who plumbed the power of detached metaphors, used objects to evoke moods, and preferred the power of suggestion over naming. No doubt Avery cultivated his American Fauve designation in the 1940s by shoring up alliances between himself and Matisse so that the proximity of their styles would serve the dual function of affirming similarities and emphasizing differences. He and his family also enjoyed thinking of him as America's Picasso, however farfetched such a comparison might be. In a family photograph made at Pemaquid Point, Maine, in 1948, for example, he plays a New England Picasso to Sally Michel's Françoise Gilot (fig. 26).

Sometimes we discern with acuity the essential qualitative distinctions on which originality is predicated when the differences are not great. The linguistic theorist Ferdinand de Saussure describes this strategy as the basic operative mode for signs: "In any semiological system, whatever distinguishes one sign from the other constitutes it. Difference makes character just as it makes value and the unity in it. . . . A term acquires its value only because it stands in opposition to everything that precedes or follows it, or to both."[95] For example, if we compare Matisse's painted nudes with those of Avery, we appreciate the latter's greater emphasis on planarity. We notice his generous use of underpainting through overlapping and contrasting layers of color, which make warm colors cool and vice versa. And we rec-

FIG. 25. HENRI MATISSE, *OPEN WINDOW, COLLIOURE*, 1905. OIL ON CANVAS, 21¾ X 18⅛ INCHES. NATIONAL GALLERY OF ART, WASHINGTON, D.C.; COLLECTION MR. AND MRS. JOHN HAY WHITNEY

ognize Avery's practice of relying on a range of hues close in value to create resonant and resolutely flat surfaces, in which each color is at peace with its neighbors. Thus, although both artists made nudes, Avery's assume an engaging candor when set next to Matisse's. This frankness may be an attribute of the artist's model, his teenage daughter, March. She is the subject of some of his most memorable nudes, such as *Nude in Black Robe* (1950; plate 8). She always posed clothed when Avery sketched her, then these sketches became the basis for abstracted nude figures.[96] Sally Michel indirectly commented on this process: "Milton's nudes are the purest nudes you ever came across, where, you know, Matisse's have an erotic quality. Milton never gets anything erotic in his work."[97] This approach was important to Avery throughout his working life, as can be seen in the important late painting *White Nude #2* (1963; plate 52), inspired by sessions drawing from live models. In these and other figure paintings he abandons the rhythmic sinuosities of Matisse's early

figure compositions, particularly his variations on the theme of dancing, in favor of an ingratiating informality manifested by figures that are often too tall or long for the compositions holding them. These figures' forthrightness is beguiling; they have a charm that has been interpreted as sincere and American, as opposed to Matisse's elegant and European orientation.

Although Greenberg is interested in Avery's American qualities, he is indifferent to their delightful candor. He appears to have been unconcerned with the Matisse/Avery connection, except for the fact that a Fauvist link is crucial to the development of his argument. Fully three-quarters into his article, he reveals that Avery's alliance with Fauvism is of central importance because of its historic challenge to Cubism's preeminence. "Through the unreal means most proper to pictorial art—the flat plane parallel to the surface," he tells us, "Avery is able to convey the integrity of nature more vividly than the Cubists could with their own kind of emphasis of the flat parallel plane."[98] Not only does Avery wield the magic wand of Fauvism that enables him to outdistance the Cubists, but "he is also one of the very few modernists of note in his generation to have disregarded Cubism almost entirely." The sentence is significant for a number of reasons. First, it places Avery in a position of unqualified eminence. Second, it transforms the Fauvist connections, which had at best been seen as conservative, into a basis for his singularity and originality. Third, it ascribes to Avery the mind of a major strategist. And fourth, this statement ignores totally the impact that Synthetic Cubism had on Matisse and the artists influenced by him—including Avery, who made full use of the interlocking planes that are a salient feature of that style. After pushing Avery to the forefront of his generation, Greenberg compares him favorably to Clyfford Still and stresses his importance for younger artists. He states that Avery "has flouted the Cubist canon of the well-made picture almost as much as Clyfford Still has."

In order to advance his argument to a crescendo before concluding it, Greenberg takes up the dubious strategy of aligning Fauvism with the unfinished project of Impressionism and then pitting the two against Cubism. In the process he underscores an inherent problem in this Fauvist/Impressionist perspective: Since it supports an art of heightened opticality and diverges from the sculptural (i.e., the tactical realm) of Cubism, it runs the risk of becoming merely decorative. Greenberg defines decoration as "tenuous flatness; pure, value-less contrasts of hue; large, 'empty' tracts of uniform color; rudimentary simplicity of design; absence of accents—sheer, raw visual substance." In his words:

It is as though Late Impressionism and Fauvism have come on the order of the day again precisely because, being so much more anti-sculptural and therefore inherently decorative than Cubism, they sharpen the problem by increasing the tension between decorative means and nondecorative ends.

According to Greenberg, the only recourse for avoiding such a qualitative descent to the decorative is monumental scale. Although he couches this statement in terms of Matisse's and Monet's art, he no doubt is thinking of the way that the wall-scale paintings of the Abstract Expressionists at times enabled them to ennoble formal elements, which the geometric abstractionists had allowed to devolve into mere decoration. Greenberg seems to have concluded that in the past size was not a viable option for Avery and even the enhanced scale of his recent work does not provide him with the necessary breadth to transform decoration into imposing grandeur.

Although monumentality is not part of Avery's repertory, Greenberg concedes that his relatively small pictures do provide an instantaneity of vision unavailable to painters working on a large scale. "A large picture can re-create the images of things, but only the relatively small one can re-create the instantaneous unity of nature as a view—the unity of that which the eyes take in at a single glance." This reading, as Greenberg unabashedly admits, is lifted in its entirety from the nineteenth-century controversy between the grand history paintings of the academics and the Impressionists' comparatively diminutive canvases. He employs the idea of an immediate, holistic vision to buttress Avery's ongoing war against the debilitating forces of abstract decoration. The artist achieves his success "by a similar naturalism [to the Impressionists], and it is this that he invokes against the decorative."[99] Rather than expunging decoration from his art, Avery, according to Greenberg, uses it to reinforce feeling.

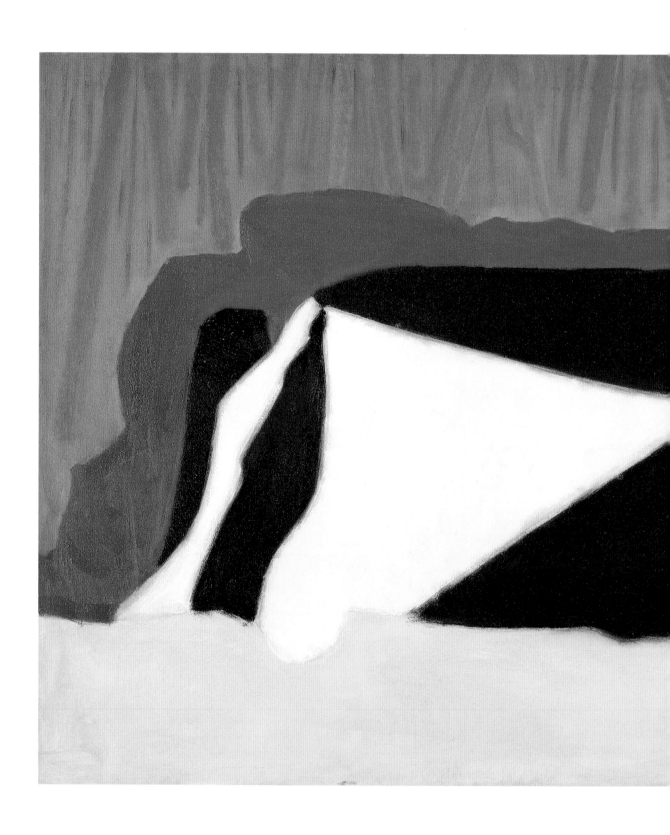

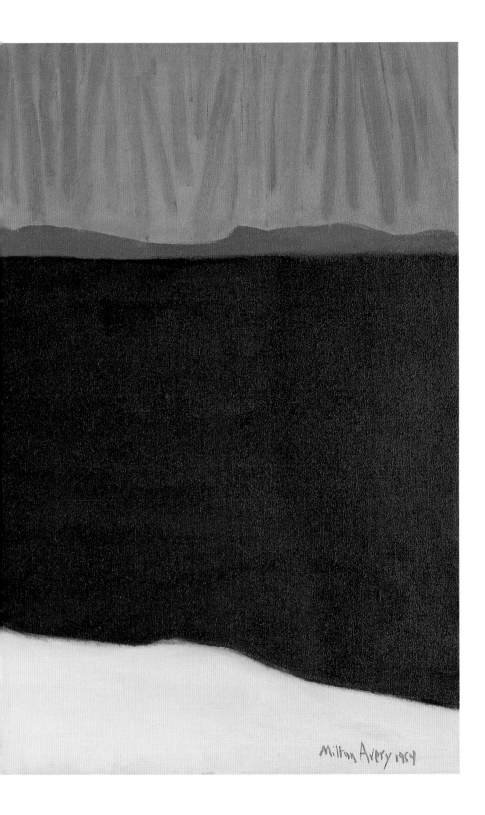

PLATE 22. *WATERFALL*, 1954

art in New York." He closes with the strategically placed admonition that "the latest generation of abstract painters in New York has certain salutary lessons to learn from him that they cannot learn from any other artist on the scene."[100]

MILTON AVERY AND A NEW POETICS

In 1935 the renowned critic for the *New York Sun*, Henry McBride, reviewed Avery's first exhibition at Valentine Gallery. In order to convey the significance of his experimentation with color, McBride employed a poetic analogy. "All of Mr. Avery's pictures seem to be the result of imagination and poetic living," he wrote, "and are not always connected with the actual world, and yet, as in the case of the wine-colored sky they have their own reasons for being, and in the end always justify themselves—to poets."[101] Evidently pleased with this association between painting and poetry, McBride heightened it the following year when he described Avery as "a poet, a colorist and a decorator; so excellent in each of these divisions that he might exist on any one of them; yet I presume that being a poet will eventually be his strongest claim."[102]

There is no way of knowing whether McBride's references stemmed from conversations with the artist or were simply fortuitous. At any rate they were exceedingly appropriate since this artist maintained an unwavering love of literature throughout his life. The first year of marriage he read Marcel Proust's *Swann's Way* to his bride. Over the years he read other classics aloud to Sally and March. In addition to novels, he enjoyed poetry as the wonderfully sympathetic painting *Poetry Reading* suggests. Michel recalled an incident on one of their extended summer vacations, when both he and March wanted to read some poetry aloud: when she chose March, Milton went upstairs and read his preferred selections to himself in such a strong voice that he could be heard downstairs.[103]

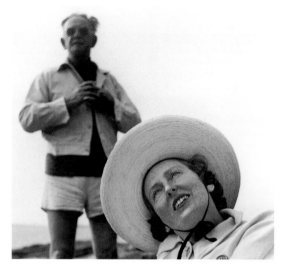

FIG. 26. SALLY AND MILTON AVERY, PEMAQUID POINT, MAINE, 1948.

COURTESY KNOEDLER AND COMPANY

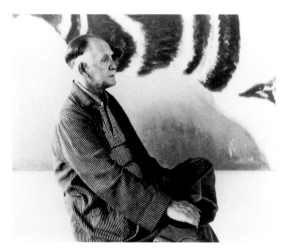

FIG. 27. MILTON AVERY, PROVINCETOWN, MASSACHUSETTS, 1960.

COURTESY KNOEDLER AND COMPANY

And this reliance on feeling, together with an acceptance of certain aspects of decoration endemic to abstract painting, makes him exemplary for younger painters. Although Greenberg does not mention them by name, he means the Color Field painters Morris Louis and Kenneth Noland. Greenberg concludes his essay on Avery with an open challenge to the art world to give this deserving painter a full-scale retrospective exhibition "not for the sake of his reputation but for the sake of the situation of

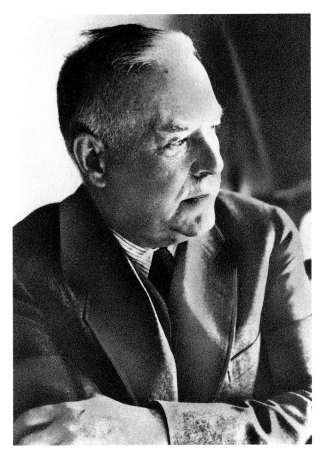

FIG. 28. WALLACE STEVENS, CA. 1954. PHOTOGRAPH SYLVIA SALMI

March Avery recalled her father's fascination with reading the dictionary and noted that over the years he would spend many evenings studying it in perfect contentment. If we consider his interest in words as analogous to his use of color, we can appreciate his intense involvement with poetry and its effects on his painting. Similar to colors, words can be used to represent objective reality and communicate feelings. Like colors, they depend on specific contexts to convey shades of meaning. An enhanced vocabulary was an enormous aid to Avery's regular readings of literature and poetry; it provided a depth and subtlety to his interpretations on a par with his understanding of art. Among the poets he liked best to read aloud, Wallace Stevens is the most consequential for his art, since his poetry expresses a personal theory, or poetics, of art's rightful purview.[104]

It is not surprising that Avery gravitated to Stevens's poetry.

Both had lived for extended periods in or near Hartford, Connecticut; both were committed to the ongoing project of modern art; both had benefited from substantial and lasting connections with New York City; and incidentally, but not inconsequentially, both had worked for insurance companies, so that practicalities found a place in their poetics. Stevens's association with Manhattan dated to the second and third decades of the twentieth century, when he renewed his friendship with his old Harvard classmate Walter Arensberg and for a brief period of time joined his circle of friends. He became acquainted with Marcel Duchamp, among the artists who congregated around the Arensbergs. Avery's connection with New York City began about the time that Stevens settled into life as an insurance executive in Hartford. The two probably never met.[105] Although Avery certainly knew and read Stevens's poetry, it is doubtful that Stevens was more than casually acquainted with Avery's art, if he was aware of it at all.[106] On the other hand, Stevens's poetic theories were a major intellectual force in the painter's ongoing efforts to work through the problems of realism and abstraction. Stevens's initial collection of poems, *Harmonium*, is known for its dazzling wordplay. Later, he became increasingly philosophical in his work and less prone to the sonorities and playful rhythms of these early pieces. His mature poems are profound works of art as well as rigorous theoretical texts. They provided Avery with in-depth analyses of the poetics and problematics of reconciling nature with the imagination—a major challenge that both poet and painter separately had set for themselves.

Because Stevens was known only to a small, highly select group of modern poetry experts until the late 1930s, Avery's initial understanding of modernism was probably not influenced by him. It was likely formed through his acquaintance with the School of Paris, and particularly with Matisse's art, as we have seen. While our earlier discussion of Matisse and Avery compares and contrasts their conscious and highly pragmatic approach to art, another aspect of their art warrants serious consideration, and this is their connection to modern poetry.

To approach this subject, we need first to reflect on an almost Byzantine layering of influences. Matisse aligns himself with the ideas of Stéphane Mallarmé and the Symbolists, and internalizes their concepts. Avery then learns from Matisse's art.

FIG. 29. EDOUARD MANET, *PORTRAIT OF STÉPHANE MALLARMÉ*, 1876. OIL ON
CANVAS, 10⅝ X 13¾ INCHES. MUSÉE DU LOUVRE, PARIS

publisher Albert Skira. She quotes Matisse on the poet: "After concluding these illustrations for the poems of Mallarmé," Matisse related, "I would like simply to state: This is the work I have done after having read Mallarmé with pleasure."[110] It should not be surprising that artists such as Matisse found Mallarmé a congenial spirit and an inspiration. He had been close to Edgar Degas, Edouard Manet (fig. 29), Claude Monet, Berthe Morisot, Odilon Redon, Pierre-Auguste Renoir, and James McNeill Whistler, all of whom attended the Tuesday evening discussions where he presented his poetic theories. One of Matisse's formal goals in the *Poésies* suite was to balance the lefthand pages that bore Mallarmé's typeset poems with the whiteness of the pages bearing his line drawings. In Barr's 1951 text for the MoMA retrospective, Matisse is quoted as comparing this task to that of a juggler working with black and white balls. "I obtained my goal," Matisse reminisced, "by modifying my arabesque in such a way that the attention of the spectator should be interested as much by the white page as by his expectation of reading the text (fig. 30)."[111] The comment reveals his reliance on ideas advanced by Mallarmé in his sonnet "Le Vierge, le vivace et le bel aujourd'hui" (The Virginal, Vibrant, and Beautiful Dawn), probably his best-known poem.

This poem is considered a key document for the entire modern movement. It develops concepts that have proven useful for artists working well into the late twentieth century. Within the space of a brief poem, Mallarmé presents a visual and figurative image of a white swan so that this creature symbolizes an actual bird, poetry itself, and the white paper on which it is printed.[112] In French *le cygne* (the swan) is a homonym for *le signe* (the sign). Thus, within the poem there are two swans: the uppercase Swan is a symbol of the absolute beauty and purity of poetry, represented by its whiteness and by its association with the constellation of Cygnus. As the poem draws to a close, its lowercase, real-life equivalent is encased in ice and snow—a reference to the white page of the poem. Frozen in the figurative and literal space of the poem, this real-life swan references the absolute Swan of poetry, encased in immortality and partaking of the universal and static beauty that is art's domain. The Swan remains connected to its mortal, lowercase counterpart, if only in sympathy for its transience. As the critic Henry Weinfield

Mallarmé's thought provides a meaningful model for Stevens, whose poetry also in turn has an impact on Avery's art.[107] Because there is little if any extant documentation on Avery's intellectual development,[108] we cannot disentangle this morass of primary, secondary, and tertiary influences. However, we can point generally to their overall importance. Avery neither theorized about his work nor indulged in personal aggrandizement by referring to his intellectual and artistic mentors, either to borrow their glory or to demonstrate his independence from them. But he did inspire the confidence and friendship of several deeply thoughtful and articulate painters; three of them—Adolph Gottlieb, Barnett Newman, and Mark Rothko—were among the most intellectual of the Abstract Expressionists. Such friendships indicate Avery's own intellectual depth. With this in mind, we may analyze the artistic and poetic theories, formative for his work, that were transformed by it.

The same year that Henry McBride complimented Avery on his poetic judgments regarding color, the art historian Adelyn D. Breeskin wrote an article entitled, "Swans by Matisse" for the *American Magazine of Art*.[109] Breeskin describes a suite of twenty-nine etchings titled *Poésies de Stéphane Mallarmé* that Matisse had completed three years earlier, at the request of the

PLATE 23. *DARK STILL LIFE*, 1954

pointed out, "It is as if the eternal [Swan] gazed down upon the temporal [one], lamenting its loss."[113] Mallarmé in the nineteenth century anticipated the self-reflexiveness that was to become a basis for modernism, in which art's material form reiterates, reinforces, and manifests its concepts so that ideas are expressed both figuratively and materially.

The idea of Mallarmé's swan is crucial for Matisse's accompanying illuminations; some additional concepts developed in his poems provide a raison d'être for other works as well. Mallarmé's essay "Crisis in Poetry" outlines a modern poetics based on ridding language of its prosaic qualities: "If the poem is to be pure, the poet's voice must be stilled and the initiative taken by the words themselves, which will be set in motion as they meet unequally in collision. And in an exchange of gleams they will flame out like some glittering swath of fire sweeping over precious stones, and thus replace the audible breathing in lyric poetry of old—replace the poet's own personal and passionate control of verse."[114] He describes this incantatory language through an analogy with a flower: "I say: a flower! And, outside the oblivion to which my voice relegates all outlines—musically the idea itself arises, the sweet idea that is absent in any bouquet."[115] An equivalent to this essential flower is to be found in a number of Matisse paintings, including his Fauvist *Open Window, Collioure*. In this work flowers are composed of individual strokes of paint in such a way that paint figures as the blossoms of art itself. This rhyming of painted and natural forms reinforces Mallarmé's famous retort: "You don't write sonnets with ideas, Degas, but with words."[116] We might pose the correlative that modern paintings tend to be made by painting ideas, not extraneous concepts, such as narrative themes. Matisse's painting approach was important to Avery, who revisited it in *March on the Balcony*. Instead of flowers, he included a red-painted equivalent to his daughter, March, who wears a version of a Romanian blouse made famous by Matisse in several works a decade earlier, thus joining metaphor and metonymy to underscore his connections with the older Fauvist.

In addition to being influenced by Mallarmé's poem and its emphasis on the essential word, Matisse repeatedly returned to the poet's concepts regarding windows and azure. The key poem for the theme of interior and exterior space revealed or obstruct-

FIG. 30. HENRI MATISSE, *PRELIMINARY DRAWING (THE SWANS, MARKED CYGNES I)*, CA. 1932. GRAPHITE ON PAPER, 13⅛ X 9⅞ INCHES. BALTIMORE MUSEUM OF ART; THE CONE COLLECTION, FORMED BY DR. CLARIBEL CONE AND MISS ETTA CONE OF BALTIMORE, MARYLAND (BMA 1950.12.903)

ed by windows is "The Windows," published in 1866. Mallarmé plays with the ambiguities of illusion and reality provided by these openings. In this poem a patient in a hospital—a symbol of human life—looks from a window and is unable to discern whether the outside view is an illusion or an unfamiliar perspective of the world. This disparity between the fictive and the real is important to Matisse in such works as *The Blue Window* (fig. 31), in which the view outside the window is like the objects inside the room, thus posing a conundrum about the nature of reality as a projection of our thoughts, rather than a distinctly separate realm. The view offered by the window also can be construed as an illusionistic painting within the room, so that art participates in a closed realm in which it pictures and reflects itself,

exposing its own distinct means and limits. In related works Avery plays on this conceit of window/opening and painting/closure by conflating the two into a single view, so that the entire work must be seen as a continually oscillating dialectic between view and painting, opening and closure. Such a contrapuntal exchange occurs in *Seabirds on a Sandbar* (1960; plate 48) and other late works, which also look like representations of representations.

Matisse's *The Blue Window* also reflects an awareness of Mallarmé's investigation of the profound cosmological breach that occurred in the modern period, when traditional belief systems began to collapse. Mallarmé symbolizes this break with the color *azur* (blue). The French word *azur* connotes not only a blue color, but also the "sky" or "heaven," without privileging either the secular or the religious term. Its meaning oscillates between these two alternatives, without resolving the problem posed by mid-nineteenth-century positivists, who regarded such unverifiable terms as "heaven" as inaccessible, imprudent, and ultimately useless. *Azur* signifies the great divide or void that developed between these two meanings, which still retain traces of their former association. The word expresses a desire for transcendence and an awareness of the futility of that longing. *The Blue Window* updates the terms of this dilemma: the problem hinges on the limits of reality versus the elasticity of illusion. Azure permeates both the room and the view through the window piercing it, transforming both into their painted equivalents. The sky is denied its traditional role as a transcendent heaven, even though aspects of its former meaning still haunt the work. Viewers of *The Blue Window* are forced to confront Mallarmé's dilemma: the alternatives of sky and heaven and literal painting versus symbol offer observers the very divergent options of empiricism and idealism. There is a continual tug of war between these options in many of Avery's landscapes and sea pictures, such as *Flight* (fig. 32), where the opposing goals of realism and abstraction set up ongoing tensions.

We cannot know whether Avery intuited this complex modern problem regarding reality and imagination from Matisse's painting or from Stevens's poetry. Most likely, his close, attentive viewing of the first reinforced his later appreciation of the latter. Stevens's 1937 poem "The Man with a Blue Guitar" is an elabo-

FIG. 31. HENRI MATISSE, *THE BLUE WINDOW*, 1911. OIL ON CANVAS, 51½ X 35⅝ INCHES. THE MUSEUM OF MODERN ART; ABBY ALDRICH ROCKEFELLER FUND

ration of Pablo Picasso's 1903 Blue Period painting *The Old Guitarist*, and also participates in Mallarmé's problem of the literal/figurative divide posed by *azur*'s sky/heaven associations. In Stevens's poem the blue guitar is a symbol of art's distilling lens, which transforms the external world into the special formal means that is poetry's purview. His poem was obviously important to Avery, who read it aloud to his wife and thematized blue in a number of works, including *Self-Portrait* and *Summer Reader*. These paintings focus on the transformative aspects of

PLATE 24. *HINT OF AUTUMN, 1954*

creative and intellectual pursuits. The poem contains this Mallarméan concept:

> Poetry is the subject of the poem,
> From this the poem issues and
>
> To this returns. Between the two,
> Between issue and return, there is
>
> An absence in reality,
> Things as they are. Or so we say.[117]

Avery probably was aware of its relevance to Matisse's art, even though he was most likely not cognizant of its Symbolist origins. In "The Man with a Blue Guitar" Stevens is concerned with the relationship between the realms extrinsic and intrinsic to art. Later, he moved into more difficult terrain: exploring reality and imagination as necessary abstractions.

The poem that focuses on the imperatives of abstraction is the recondite "Notes Toward a Supreme Fiction," whose first major section bears the imperative subheading "It Must Be Abstract." This section enjoins a young man to entertain the concept of abstraction:

> Begin, ephebe, by perceiving the idea
> Of this invention, this invented world,
> The inconceivable idea of the sun.
>
> You must become an ignorant man again
> And see the sun again with an ignorant eye
> And see it clearly in the idea of it.[118]

Stevens develops a complex theory of the first idea, which for several reasons must be abstract. First, as Socrates told Cratylus, abstraction is necessary for gaining access to the world, otherwise we would be forced to cope with the individual objects of the world in their inexhaustible variety and specificity. Because a concept (or sign) can never be the same as its material equivalent, it represents an impoverishment of reality. Although Stevens does not refer to it, this is the underlying significance of

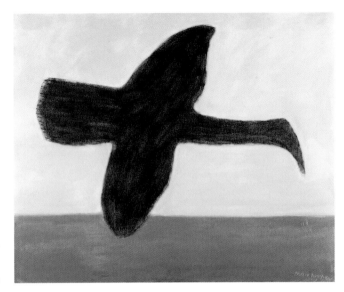

FIG. 32. MILTON AVERY, *FLIGHT*, 1959. OIL ON CANVAS, 40 X 50 INCHES.
COLLECTION MARGO COHEN, COURTESY DONALD MORRIS GALLERY, NEW YORK

the parable of Adam and Eve, whose acquisition of knowledge caused them to be ostracized from the Garden of Eden, and to lose their original fullness and consanguinity. Before Eve's birth, Adam used abstraction, without appreciating it, when he gave all living creatures their names. No matter how much of a nominalist one hopes to become, one's thoughts and descriptions—verbal and visual—never equal their living referents. Even the photographer is forced to abstract from reality—hence Stevens's injunction, "It Must Be Abstract." Human beings have no other choice: our formal languages force us into abstraction. This lack is acknowledged and even celebrated in Avery's *Stormy Day* (1959; plate 41), which translates inclement weather into a set of abstract notations communicating the concept of a storm but not its unwieldy specificity.

Stevens suggests that the only way to avoid the trap of abstraction is to return to a prelapsarian dawn, to see the world in its wondrous and unadulterated harmony of being. Of course, such a feat is impossible, since seeing is itself a form of abstraction. Because of this, the imperative "It Must Be Abstract" is directed not just to the young man in the poem but to all of humanity. It is an undeniable fact: all human intelligence is abstract; it is a delimitation of the world. Stevens counsels the

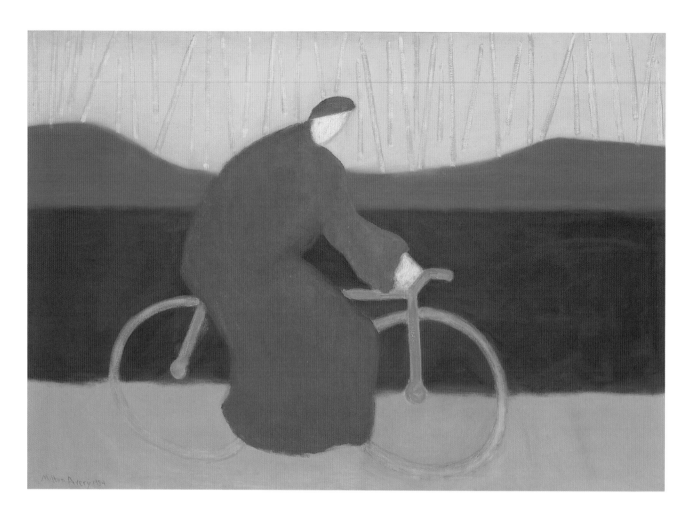

PLATE 25. *BICYCLE RIDER BY THE LOIRE*, 1954

ephebe that Phoebus Apollo is no longer living, "But Phoebus was / A name for something that never could be named. . . . The sun / Must bear no name, gold flourisher, but be / In the difficulty of what it is to be."[119] Although the term "gold flourisher" might be considered a designation for Apollo (and thus a name for the sun), as some scholars have suggested, it most likely addresses the ephebe, whose inexperience makes him prone to name that which cannot be labeled and thus demonstrate his ignorance of Stevens's first injunction.

In the second section of "Notes Toward a Supreme Fiction" Stevens points to "the celestial ennui. . . . / That sends us back to the first idea." He notes that "the first idea becomes / The hermit in a poet's metaphors"[120] because it describes its own isolation from reality, since language reconfigures the world into its own form, thereby limiting it. Stevens's description of the first idea can be understood as a repeating cycle in which we attempt to clarify our understanding of the world, but are unable to do so. The reason for this Sisyphean labor is that the language used to convey the first idea is subject to time: constantly in danger of becoming hackneyed. Thus, the first idea must be continually reposited in new ways to maintain its freshness and primacy, as well as to circumscribe anew—and hopefully with more precision—what is ultimately unknowable and beyond definition.

The frustration of positing the first idea can be understood by analogy with another concept that is equally difficult to come to terms with: the philosopher Jacques Lacan's definition of the real as that which evades being symbolized. Further into the

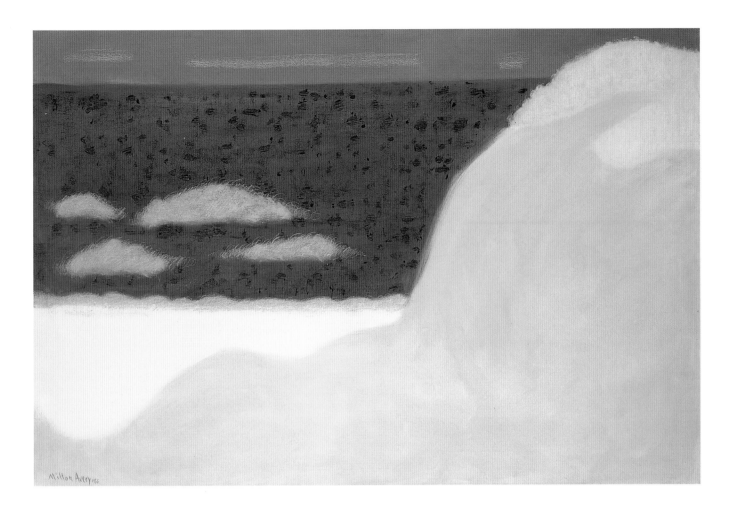

PLATE 26. *SEA AND SAND DUNES, 1955*

poem, Stevens describes the world in terms consonant with the Lacanian concept of the real:

> *Not to be realized because not to*
> *Be seen, not to be loved nor hated because*
> *Not to be realized.*[121]

Then Stevens compares the first idea (that is, the first attempt to label the real), with the difficulty in coming to terms with weather in the canvases of the Dutch Baroque painter Franz Hals. This exercise represents an impossibility, since Hals painted only figures in interiors, never outdoor scenes. Stevens permits his readers the latitude to discover this fact for themselves, so that he can dramatize the futility of the first idea rather than merely describe it. When he adumbrates this description of the weather with the stanza, "It must be visible or invisible, / Invisible or visible or both: / A seeing and unseeing in the eye," he takes Mallarmé's *azur* in the direction of the limitation of perception.

At this point in the "Notes" Stevens supplies Avery with a theoretical basis for his own works, which are similarly involved in a seeing/nonseeing dialectic. They not only reflect his view of figures and landscapes but also image the abstract, painted lens through which they are conveyed. This is evident in most of his works, including *Madonna of the Rocks* (1957; plate 30) and *The White Wave*. In this way, Avery's works are doubly abstract. Their realism is tempered to at best an idiosyncratic perspective; and their emphasis on the process of seeing removes them from the ambition of claiming a direct apprehension of reality. These ver-

For Stevens, this war is unending. The first idea may only circumscribe reality without transforming it, leaving it to dwell in a primordial obscurity, which we can intuit even if we cannot directly apprehend it:

> *The poem refreshes life so that we share,*
> *For a moment, the first idea. . . . It satisfies*
> *Belief in an immaculate beginning.*[123]

The poet's metaphors die because the first idea is not, and can never be, the thing in the world, but only its artistic representation. As Stevens points out, "The first idea is an imagined thing."[124] Thus, he regards the first idea not as an ultimate goal but as a continuum that persists in referring to the real in fresh and insightful ways. But this repetition of the new encumbers the first idea with ennui, leaving it on a trash heap of worn-out metaphors and fashionable thoughts:

> *The poem goes from the poet's gibberish to*
> *The gibberish of the vulgate and back again.*
> *Does it move to and fro or is it of both*
>
> *At once? Is it a luminous flittering*
> *Or the concentration of a cloudy day?*
> *Is there a poem that never reaches words*
>
> *And one that chaffers the time away?*[125]

The notion of the "poem that never reaches words" implies that poets and other creative individuals must begin again, searching always to find a new way of couching the next first idea, even when newness itself is suspect. Each new metaphor creates a situation in which "The poem, through candor, brings back a power again / That gives a candid kind to everything."[126]

Stevens's dynamism and open-endedness make him particularly attractive to an artist like Avery, who is caught up in the process of visualization. Like Stevens's poems, Avery's paintings function as epistemological signposts on the route to learning and relearning how to posit the first idea, rather than making eternal, sterile pronouncements regarding its universal charac-

FIG. 33. MILTON, SALLY, AND MARCH AVERY, WOODSTOCK, NEW YORK, SUMMER 1951. COURTESY KNOEDLER AND COMPANY

sions of abstraction take the form of the first idea, which is a contingent picture of reality. Avery acknowledges, but cannot reproduce in his art, another type of abstraction, which suggests transcendence since it is found only in the realm of thought. The creation of the idea of God was Stevens's favored example of this form of abstraction, since he regarded the human fabrication of divinity as the ultimate fiction.

The Mallarméan theme of *azur* is invoked again toward the end of the "Notes," when Stevens addresses the continual warfare between imagination and reality:

> *Soldier, there is a war between the mind*
> *And sky, between thought and day and night. It is*
> *For that the poet is always in the sun.*[122]

CONCLUSION

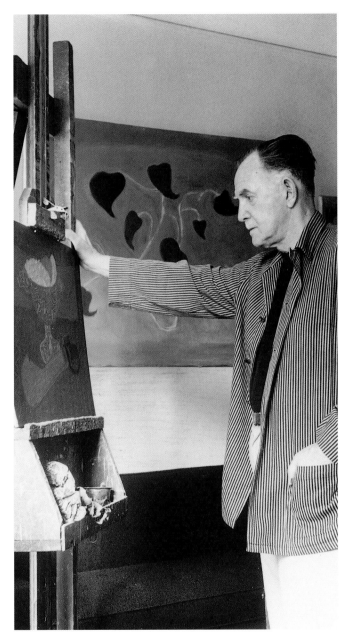

FIG. 34. MILTON AVERY IN HIS STUDIO, 1950.

PHOTOGRAPH BUDD, COURTESY KNOEDLER AND COMPANY

Milton Avery inadvertently set up enormous stumbling blocks to an understanding of his art. An incredibly quiet man, he could spend an evening with friends or a day with his wife and say only a few words. When he did talk about his art, he usually made only brief comments that deflected attention from it. He would say, for example, "I'm like a shoemaker, this is my job."[127] Or he would advise other artists in terms that sound platitudinous although they were no doubt genuinely felt: "Keep painting— day in—day out. Be absorbed by it. Hold on to the dream—try to make the great dream a reality."[128] Even his renowned wit could be a disservice to him. His wife offers this anecdote:

Once a businessman came to look at some paintings, and Milton showed him a landscape, and it had blue trees. And this man knew we had spent the summer in Vermont, and he said, I never saw a blue tree in Vermont. And Milton said, but this was New Hampshire.[129]

For all its charm, this story and others like it emphasize Avery's sense of humor at the expense of his art's cogency. Rare are the instances when he abandoned his customary habit of silence and spoke eloquently about his art, and most of them have been cited here, so that he may appear more forthcoming than he actually was.

Besides his taciturnity, Avery cultivated an appearance of naïveté that was a hurdle to many critics. This deliberate ingenuousness placed his work firmly in the context of the American folk-art tradition, along with that of Charles Sheeler and other early-twentieth-century artists.[130] Avery often expressed his deliberate gaucheries with such piquancy and dry wit that viewers were left wondering if he was a primitive, or only feigning. Critics often felt the need to emphasize his educated eye in order to avoid such misunderstandings; sometimes, in the process, they confirmed other misconceptions. In a 1952 essay, for example, the critic Dorothy Gees Seckler wrote, "Avery, who is not a primitive—he has had an acknowledged reputation as a

ter. Their contingency is evident in their thin washes, insistent freshness, improvisatory color combinations, softly nuanced purfles, and seemingly accidental resolution of realistic and abstract components.

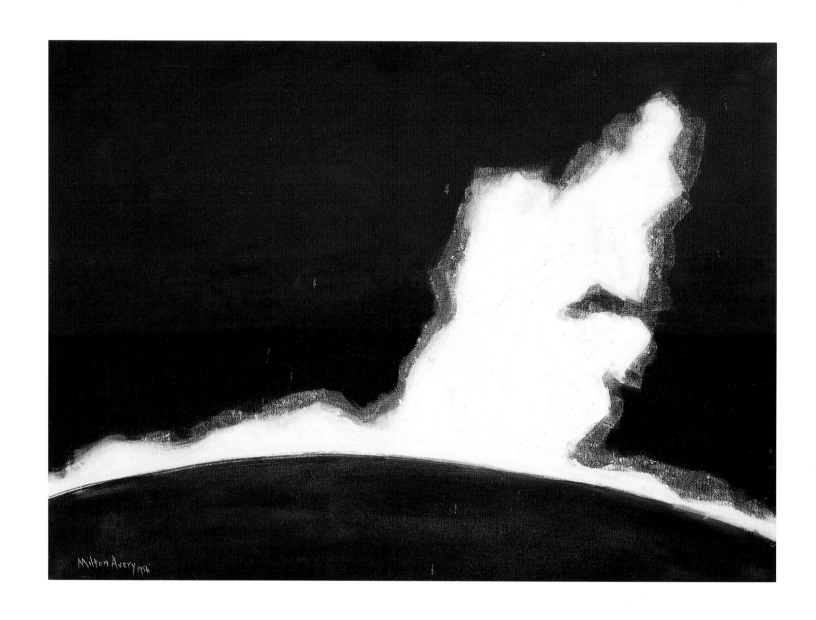

PLATE 27. *THE WHITE WAVE*, 1956

sophisticated colorist for decades—shares with the true primitive a belief that the miracle of creation is 'out there.'" Although she dispelled one myth, Seckler succumbed to another when she described Avery as a naïf: "When a person with a naïve point of view [such as Milton Avery] comes on the scene at a time when the stage is set for the sophisticated appreciation of naïveté, the most unexpected good luck can result."[131] While he does not fall into the trap of believing Avery to be a Rousseauan innocent, the artist and critic Donald Judd does ascribe these qualities to his art:

Avery's work has a couple of salient qualities. One is the naïve quality produced by the awkward drawing and placement, the flat, thin and inartistic application of the paint, the wide areas of color and by the color itself. The second quality is a certain kind of moral earnestness; partly it's a way of thinking by opposites. I can't place it more exactly. Its source in the paintings is clearer.[132]

Although Judd later refers to Avery's indebtedness to Matisse, he maintains a residual belief in his primitive orientation.

When thinking about Avery's contributions, we would be well advised to reassess one of his favorite quips. "When people ask me how long it took," Avery explained, "I say 30 years. That's how long the preparation took."[133] The humor of this statement disguises its truth, for Avery did undergo one of the longest art apprenticeships on record. The intensity and thoroughness of his formal training, coupled with years of self-schooling, enabled him to separate the process of painting into stages: a generative, conceptual phase and an executive, process-oriented one. In the first he conceived the complete work almost in its entirety, much as an experienced chess player plans a number of strategies before making a move. In the second he would paint an entire canvas quickly, so that it retained the freshness of a wonderful accident. When asked, "How can you paint a big picture so quickly?" he replied, "because I've already painted it in my head. . . . Just putting it on the canvas, that's nothing."[134] This process

explains the truth behind the artist's wisecrack, "I never have any rules I follow. I follow myself."[135] While most decisions were made before the brush touched the canvas, he did permit himself the freedom to improvise with color, since the application of one hue would often determine the choice of the next one.

This investigation of Avery's late period has focused substantially on the generative phase of his art. Its goal has been to understand the brief state in which a work is conceived as the culmination of a lifetime of events. Avery's experiences include decades studying modern art and years listening to, and participating in, conversations about art with colleagues such as Gottlieb, Newman, Rothko, and others. Long nights were spent reading aloud masterpieces of literature, particularly poetry, and pursuing the wonders of language in dictionaries. In order to gain admittance to the privileged realm that Avery kept so securely locked in his habitual silence, I have employed two tactics: I have used Greenberg's revealing essay on Avery as a diagnostic tool to ascertain the temper of the times in which he worked. I have buttressed my investigation of the purview of Greenberg's essay with Bourdieu's theory of the cultural field as a contentious terrain in which aesthetic ideas representing different ideological attitudes vie for supremacy. In this way Avery's art, which in the past has been regarded as an anomalous and idiosyncratic production, is reinscribed within its proper historical and intellectual context. My second tactic has been to take seriously the many references to Avery as a poet made by McBride, Rothko, and others. This characterization was intended as the highest form of compliment; to understand it, I have unraveled some of the complex interconnections that join Avery to Matisse, Matisse to Mallarmé, Stevens to Mallarmé, and Avery to Stevens. In the course of this inquiry it has been possible to discern a sophisticated modern poetics at the basis of Milton Avery's art. The intention of this undertaking is to reconnect Avery's art with its times and to demonstrate its subtle understanding of the advantages and limitations involved in cohering realism with abstraction. ✦

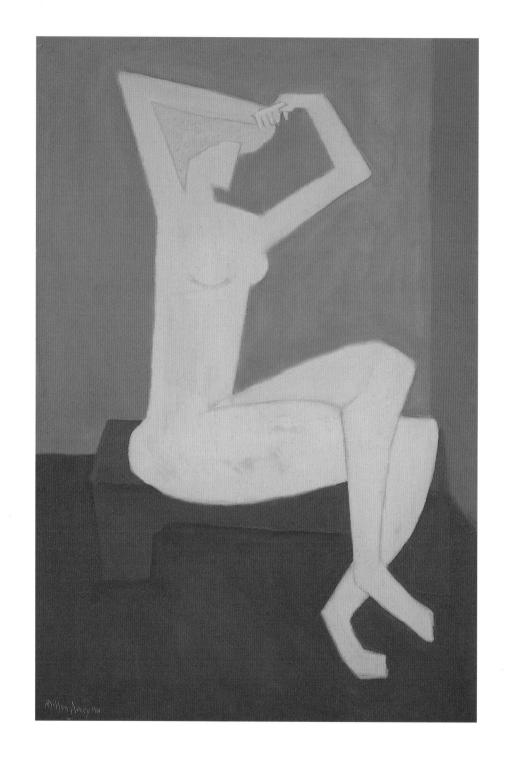

PLATE 28. *NUDE COMBING HAIR*, 1954

Of Modern Poetry

The poem of the mind in the act of finding
What will suffice. It has not always had
To find: the scene was set; it repeated what
Was in the script.
 Then the theatre was changed
To something else. Its past was a souvenir.
It has to be living, to learn the speech of the place.
It has to face the men of the time and to meet
The women of the time. It has to think about war
 And it has to find what will suffice. It has
To construct a new stage. It has to be on that stage
And, like an insatiable actor, slowly and
With meditation, speak words that in the ear,
In the delicatest ear of the mind, repeat,
Exactly, that which it wants to hear, at the sound
Of which, an invisible audience listens,
Not to the play, but to itself, expressed
In an emotion as of two people, as of two
Emotions becoming one. The actor is
A metaphysician in the dark, twanging
An instrument, twanging a wiry string that gives
Sounds passing through sudden rightnesses, wholly
Containing the mind, below which it cannot descend,
Beyond which it has no will to rise.
 It must
Be the finding of a satisfaction, and may
Be of a man skating, a woman dancing, a woman
Combing. The poem of the act of the mind.

Wallace Stevens

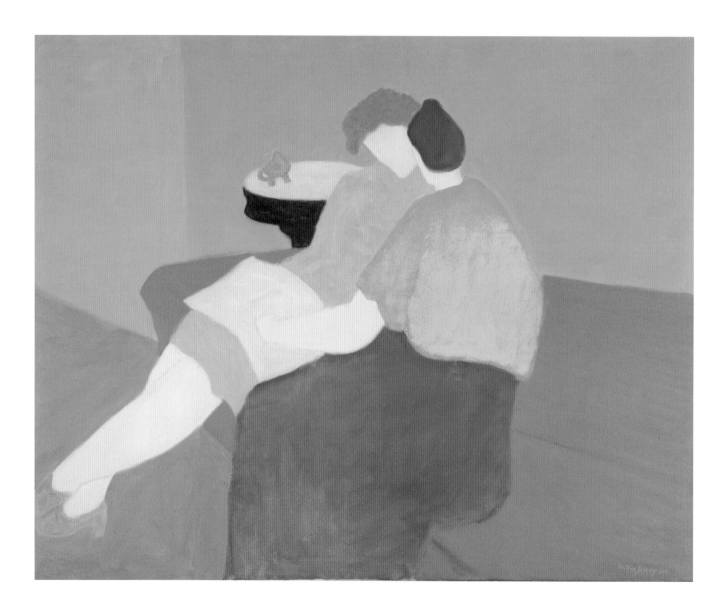

PLATE 29. *POETRY READING,* 1957

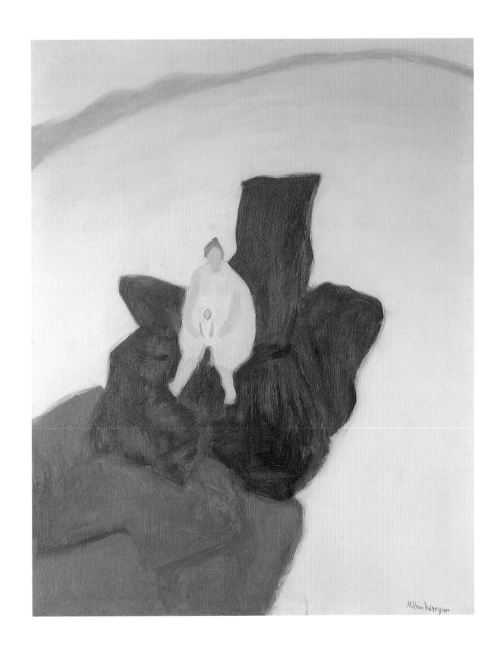

PLATE 30. *MADONNA OF THE ROCKS*, 1957

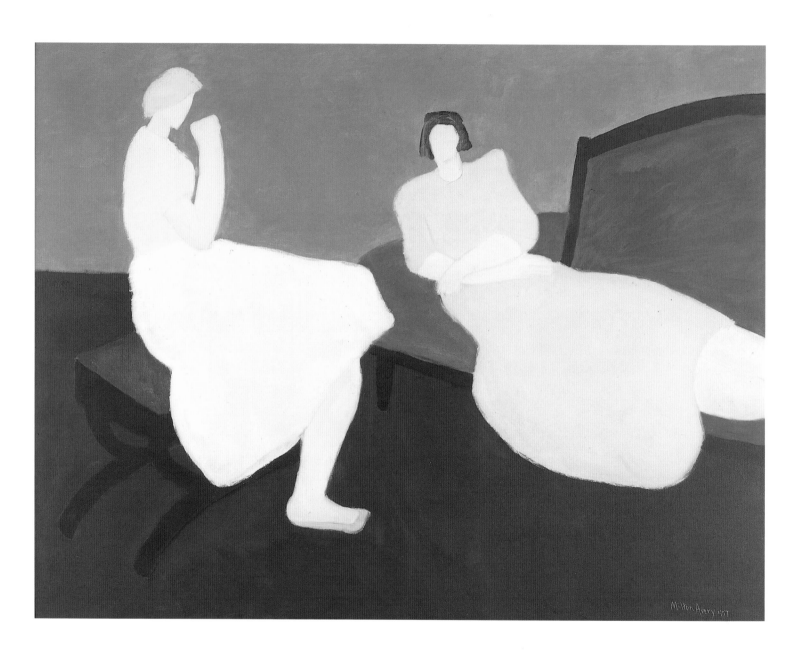

PLATE 31. *TWO FIGURES*, 1957

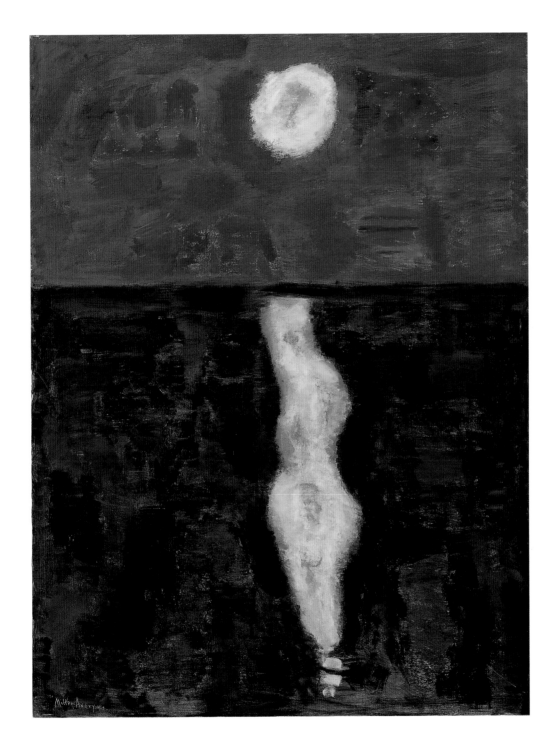

PLATE 32. *WHITE MOON, 1957*

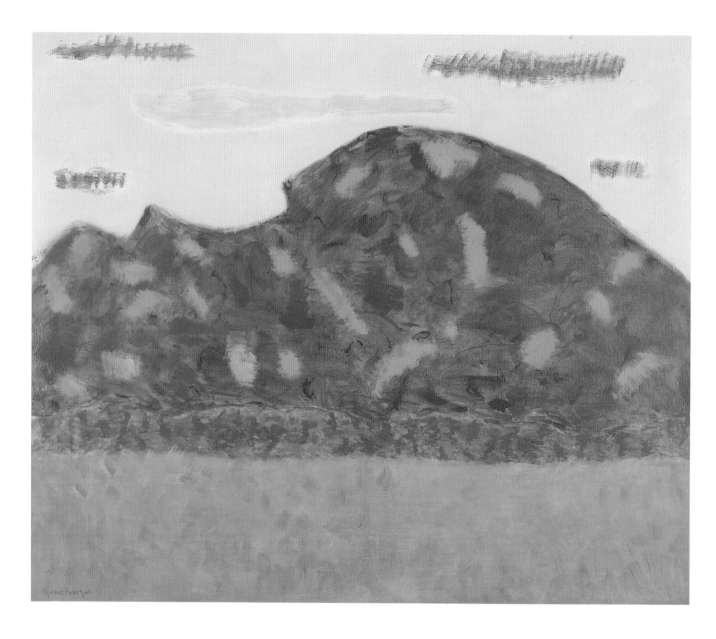

PLATE 33. *DARK MOUNTAIN*, 1958

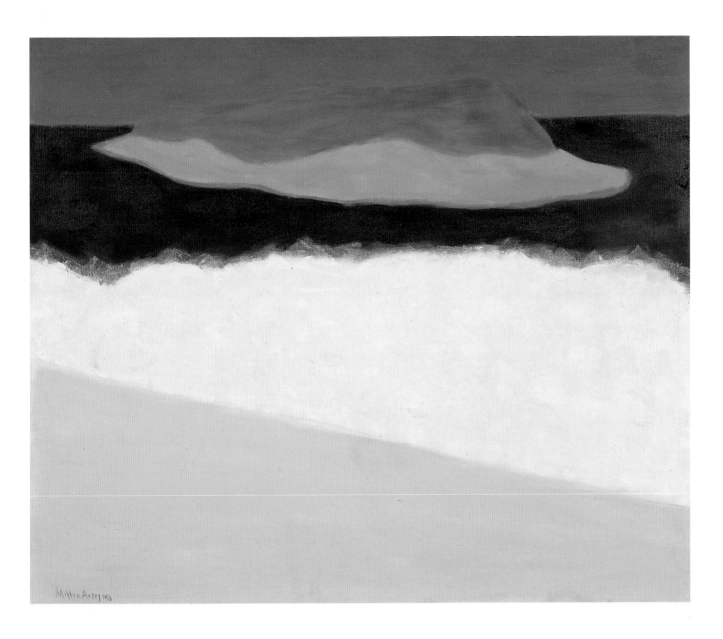

PLATE 34. *OFFSHORE ISLAND*, 1958

MILTON AVERY

BY CLEMENT GREENBERG

Clement Greenberg wrote the essay Milton Avery *in 1957, publishing it in* Arts *magazine in December of that year. The following year he revised it substantially in preparation for publication in a collection of his writings,* Art and Culture, *which appeared in 1961. The Clement Greenberg Estate considers the later version definitive. However, for the sake of historical accuracy, the original magazine article is quoted in the preceding essay.*

Milton Avery grew up as a painter in the days of the American Scene movement, with its advocacy of an art that would concentrate on American life and shun esoteric influences. Avery set his face against this, yet the atmosphere created by that movement may have helped confirm him in his acceptance of himself. However misguided and even obscurantist the American Scene tendency was, it did at least urge in principle that the American artist come to terms with the ineluctable conditions of his development; it did remind him that he could not jump out of his skin; and it did prepare for the day when he would stop bewailing the effect that he lived where he did.

In any case, Avery started off from American art before the American Scene was heard of; in Hartford, where he grew up, he looked harder at Ryder and some of the American Impressionists than at anything in French art. And when he went on to assimilate certain French influences the outcome was still some of the most unmistakably and authentically American art that I, for one, have seen.

Avery himself would be the last to see any aesthetic value in Americanness as such. If his art is so self-evidently American, it is because it so successfully bodies forth the truth about himself and his condition, not because he has ever made an issue of his national identity. And it may also be because he developed, owing to circumstances he only half-chose, within what was to a great extent a non-European frame of reference. There are, moreover, different kinds of Americanness, and Avery's kind may be more apparent than others at this moment only because it had less of a chance, before the advent of Fauvism, to express itself in ambitious, sophisticated painting.

Frederick S. Wight, in his text for the catalogue of Avery's retrospective at the Baltimore Museum in December 1952, put his finger on one of the most salient traits of Avery's art: its insistence on nature as a thing of surface alone, not of masses or volumes, and as accessible solely through eyes that refrained from making tactile associations. Avery's is the opposite of what is supposed to be a typical American attitude in that he approaches nature as a subject rather than as an object. One does not manipulate a subject, one *meets* it. On the other hand, his employment of abstract means for ends—which, however, subtly or subduedly naturalistic, are nevertheless intensely so—is nothing if not American. I see something similar in four other American artists who belong to twentieth-century modernism: Dove, Arnold Friedman, Hartley and Marin. And it is significant that except for Friedman these painters, though they all flirted with Cubism once it was on the scene, continued to find in Fauvism the kind of modernism most congenial to themselves—which is also true of Alfred Maurer, if in a different way.

The original French Fauves were usually ready to sacrifice the facts of nature for a happy decorative effect; whereas these Americans tended to let the decorative effect go when it threatened to depart too much from the facts. It was in the facts primarily that they found inspiration, and when they did not find it there they were liable (at least Dove, Marin and Hartley were) to succumb to artiness. There was a certain diffidence in this attitude: unlike Matisse, the American Fauves did not proclaim themselves sovereigns of nature. But there was also a certain courage: they clung to the truth of their own very personal experience, however intimate, modest, or unenhanceable that truth was. This applies to Avery in particular. No matter how much he simplifies or eliminates, he almost always preserves the local, nameable identity of his subject; it never becomes merely a pretext. Nor is art ever for him the peculiarly transcendent issue it often becomes for Hartley and Marin.

PLATE 35. *ONRUSHING WAVE*, 1958

There is no glamor [*sic*] in Avery's art; it is daring, but it is not emphatic or spectacular in its daring. In part this may have to do with the concrete elements of his painting: the absence of pronounced value contrasts on the one hand, and of intense color on the other; the neutral surface that betrays neither "paint quality" nor brushwork. But it has even more to do with his temperament, his diffidence. Fifteen years ago, reviewing one of his shows at Paul Rosenberg's in *The Nation*, while I admired his landscapes, I gave most of my space to the derivativeness of the figure pieces that made up the bulk of the show, and if I failed to discern how much there was in these that was not Matisse, it was not only because of my own imperceptiveness, but also because the artist himself had contrived not to call enough attention to it.

I still quarrel with Avery's figure pieces, or at least with most of them. Too often their design fails to be total: figures are not locked securely enough in place against their backgrounds,

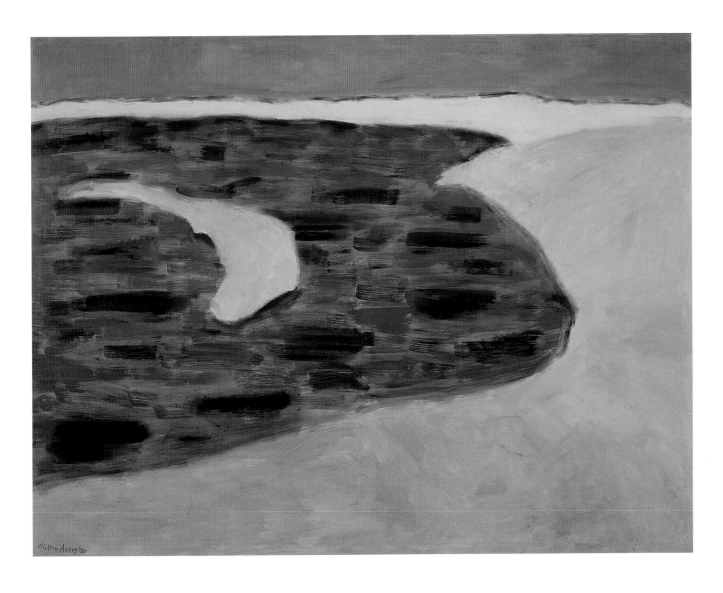

which are so often blank ones. And for all the inspired distortion and simplification of contour, factual accidents of the silhouette will intrude in a way that disrupts the flat patterning which is all-important to this kind of painting. It is as though Avery had trouble handling displaceable objects when they exceeded a certain size, and found his certainty only in depicting things that had grown into the places they occupied and which provided fore-grounds and backdrops that interlocked of their own accord. In other words, he is generally at his best in landscape and seascape.

It is difficult to account for the individuality of Avery's art. In detail it echoes many other painters—Matisse, Dufy, Hartley (who was himself influenced by Avery in the end), even Marin—but these echoes do not lead toward Avery's specific results, his pictorial unities. It is not a question of schools or styles, or even of sensibility, but of something even more personal. There is the sublime lightness of Avery's hand on one side,

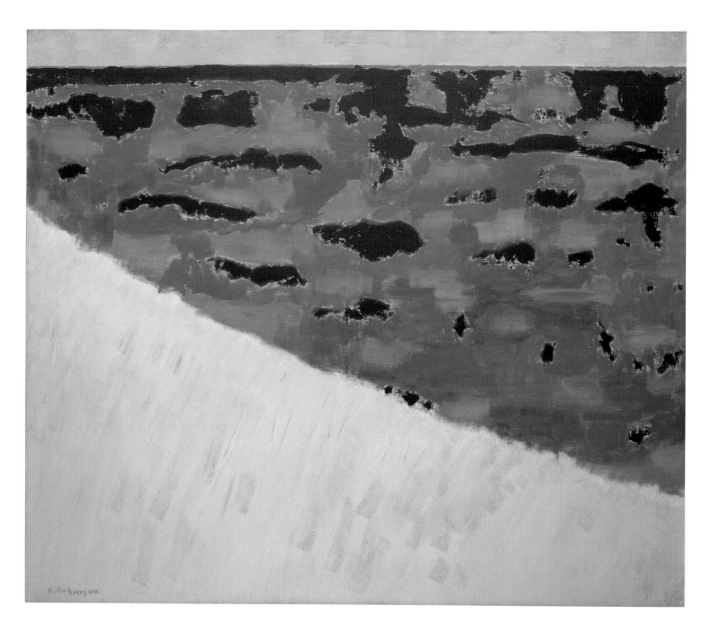

PLATE 38. *SEA GRASSES AND BLUE SEA, 1958*

and the morality of his eyes on the other: the exact loyalty of these eyes to what they experience. The question has to do with *exactly* how Avery locks his flat, lambent planes together; with the *exact* dosage of light in his colors (all of which seem to have some admixture of white); with *exactly* how he manages to keep his pictures cool in key even when using the warmest hues; with *exactly* how he inflects planes into depth without shading, and so on. Of course, all successful art confronts us with this factor of exactness, but rarely does the necessity of exactness cover as much at it does in Avery's case.

Nature is flattened and aerated in his painting, but not deprived in a final sense of its substantiality, which is restored to it—it could be said—by the artistic solidity of the result. The picture floats but it also coheres and stays in place, as tight as a drum and as open as light. Through the unreal means most specific to pictorial art, the flat plane parallel to the surface, Avery conveys the integrity of nature better than the Cubists could with their own kind of emphasis on flat parallel planes. And whereas Cubism has to eventuate in abstraction, Avery has developed and expanded his art without having either to court or ward off that possibility. As it happens, he is one of the very few modernists of note in his generation to have disregarded Cubism. It would be hazardous to say that he has not been affected by it in any way, but it certainly has not had an important part in his formation, and he has flouted the Cubist canon of the well-made picture almost as much as Clyfford Still has.

Like almost every other modernist reaction against Impressionism, Avery's Fauvism has but drawn a further consequence of it. His art is an extremer version of a world from which sculpture and all allusions to the sculptural have been banished, a world in which reality is solely optical. But what marks off Avery's painting within modernism itself is its explicit rejection of the decorative—a rejection given its point, as it is in Matisse's case, by the fact that Avery's means are so very decorative in themselves. If decoration can be said to be the specter that haunts modernist painting, then part of the latter's formal mission is to find ways of using the decorative against itself. It is as though Late Impressionism and Fauvism have come on the order of the day again precisely because, being so much more antisculptural and therefore exposed to the decorative more than Cubism, they dramatize the problem by increasing the tension between decorative and nondecorative ends.

Matisse and the later Monet overcame decoration by their success in achieving the monumental; they established size as well as scale as an absolute aesthetic factor. Avery seems never to have considered this solution. Perhaps it would have taken him too far away from his conception of nature, which could be rendered only through the easel, not the wall, painting; a large picture can give us images of things, but a relatively small one can best re-create the instantaneous unity of nature as a *view*—the unity of that which the eyes take in at a single glance. (This, even more than their revulsion against the academic "machine," seems to me to account for the size of canvas, averaging two feet by one and a half, that the Impressionists favored.) Though Avery converses with decoration in a way that would have shocked Pissarro, and in going from sketch to finished canvas distorts nature expressively, he is moved nevertheless by a naturalism not too unlike that which guaranteed Pissarro, as it did not Monet, against the pejoratively decorative.

That the younger "anti-Cubist" abstract painters who admire Avery do not share his naturalism has not prevented them from learning from him any more than it has prevented them from admiring him. His art demonstrates how sheer truth of feeling can galvanize what seem the most inertly decorative elements—a tenuous flatness; pure, largely valueless contrasts of hue; large, unbroken tracts of uniform color; an utter unaccented simplicity of design—into tight and dramatic unities in which the equivalents of the beginning, middle and end of the traditional easel picture are fully sensed. His painting shows once again how relatively indifferent the concrete means of art become where force of feeling takes over.

Painters and even collectors have paid more attention, so far, to Avery than critics or museum people have, and his reputation is not yet a firmly established one. Perhaps it is because he has been so badly selected and shown by his dealers. But it may also be because of that subtleness to which his exactness is so important. When subtleness as such becomes an important issue, the usual implication is that the art in question does not excel by its range. And the question does suggest itself whether Avery's art, for all its real variety, does not tend to be somewhat narrow in its *impact*. Such a limitation might explain why Avery, like Marin, and like Paul Nash in England, has proved unexportable so far. But one hesitates to accept this explanation, just as one hesitates to accept the idea of unexportability in general. There are certain seascapes Avery painted in Provincetown in the summers of 1957 and 1958 that I would expect to stand out in Paris, or Rome or London just as much as they do in New York. ✦

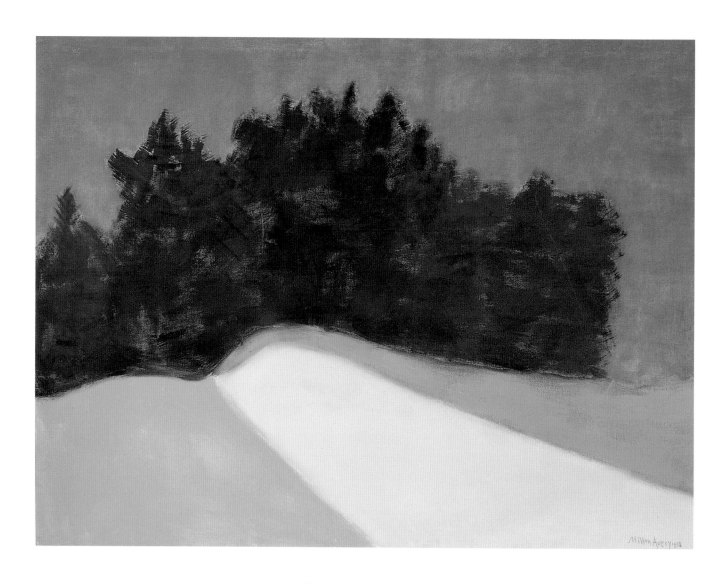

PLATE 39. *DARK FOREST, 1958*

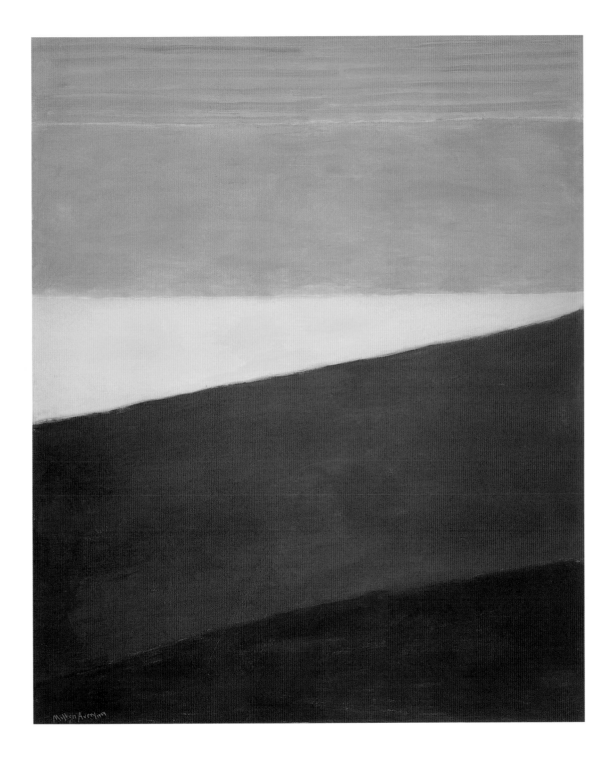

PLATE 40. *BOATHOUSE BY THE SEA, 1959*

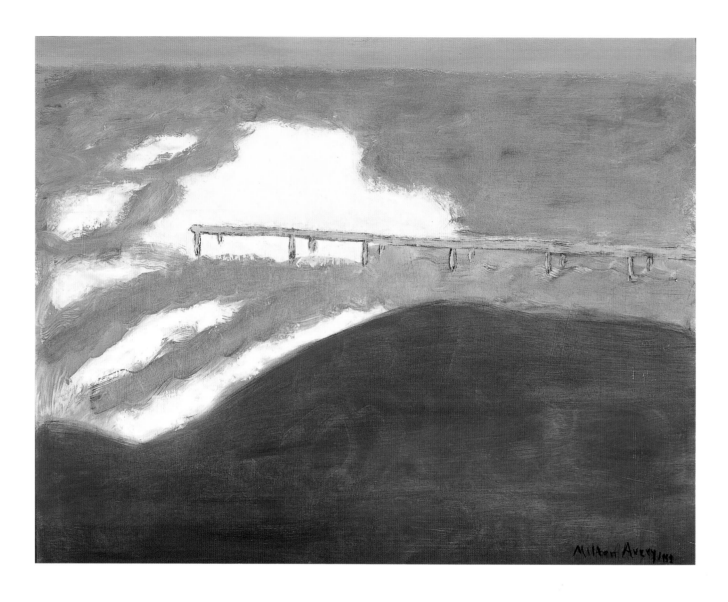

PLATE 41. *STORMY DAY, 1959*

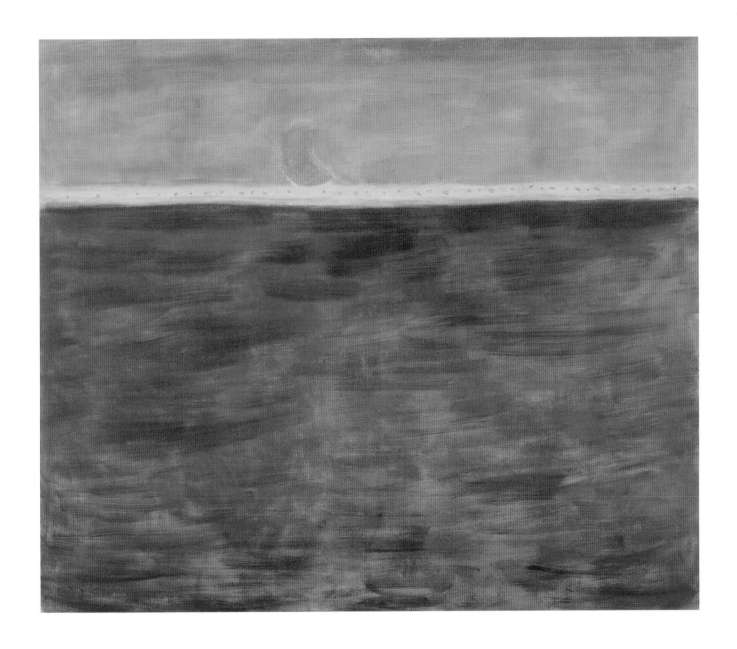

PLATE 42. *TANGERINE MOON AND WINE DARK SEA*, 1959

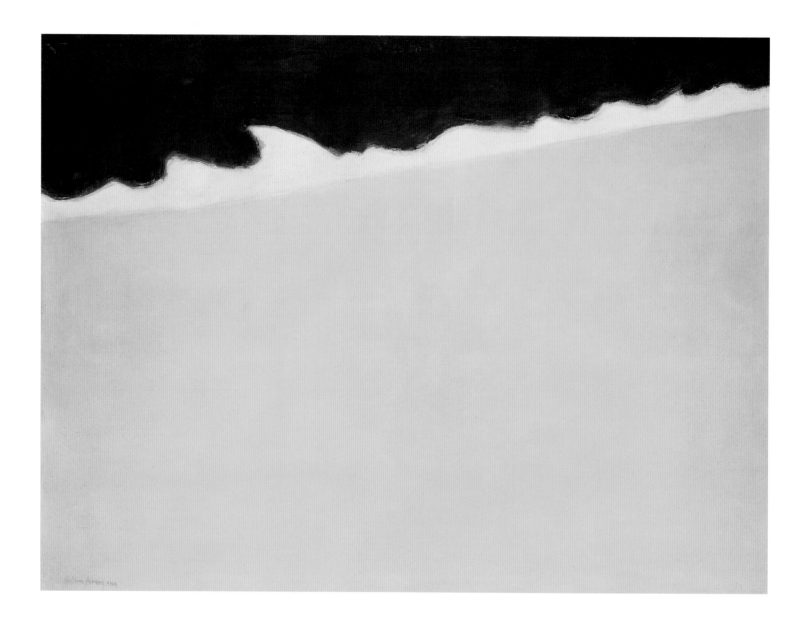

PLATE 43. *BLACK SEA*, 1959

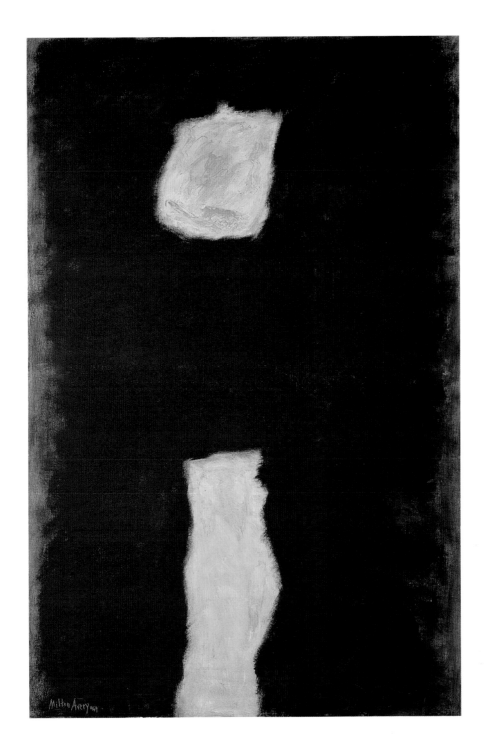

PLATE 44. *BLACK NIGHT, 1959*

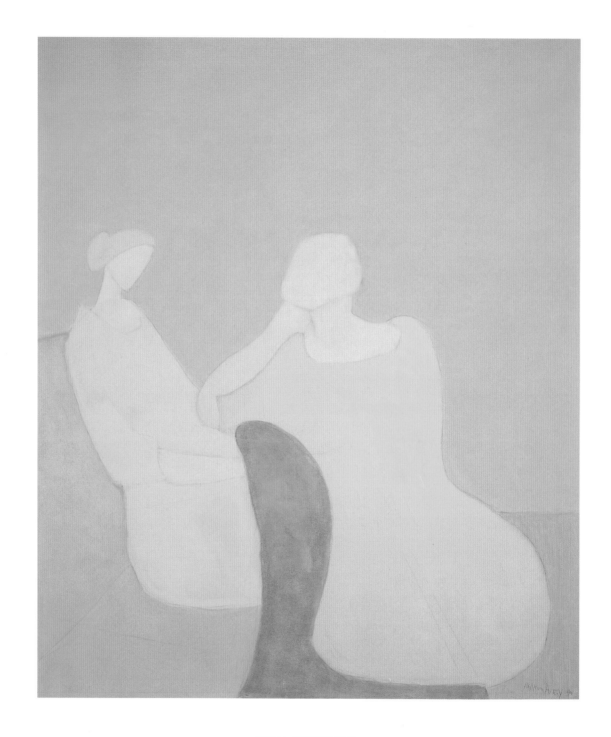

PLATE 45. *INTERLUDE*, 1960

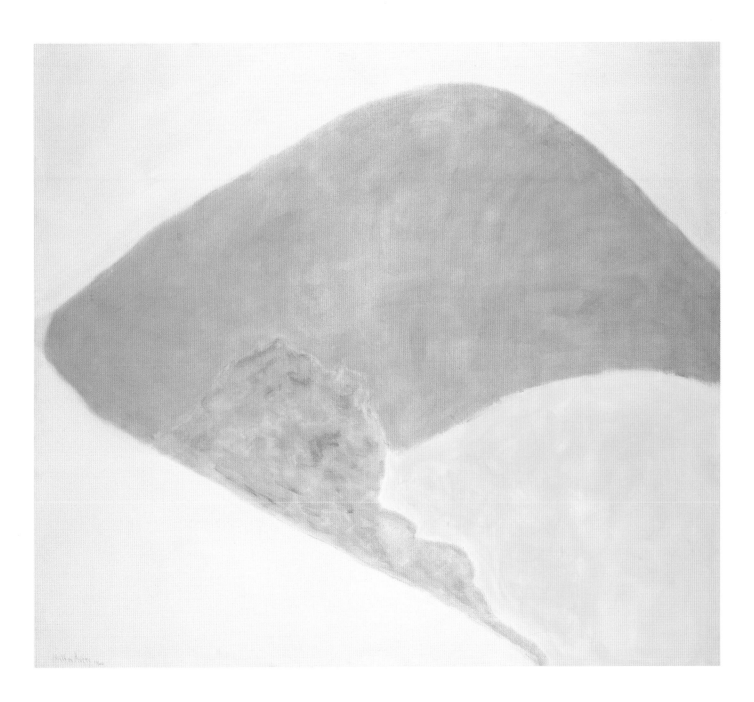

PLATE 46. *MOUNTAIN AND MEADOW, 1960*

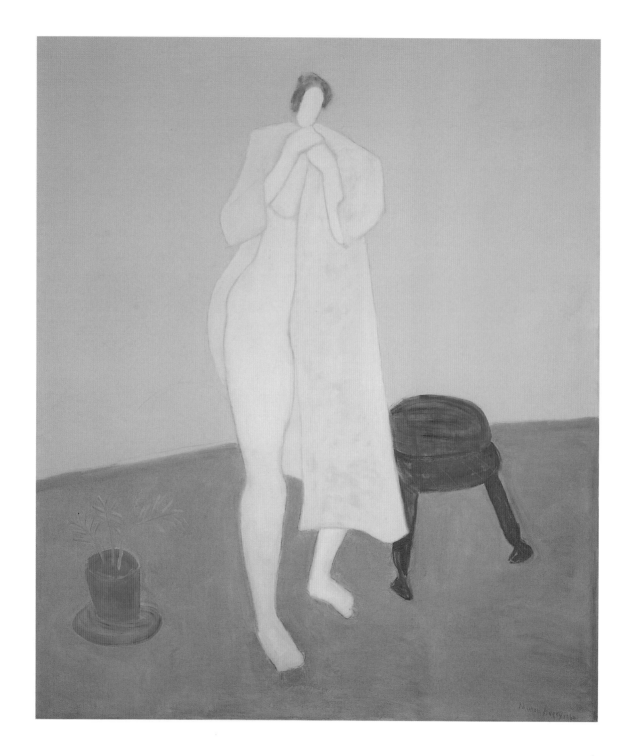

PLATE 47. ROBED NUDE, 1960

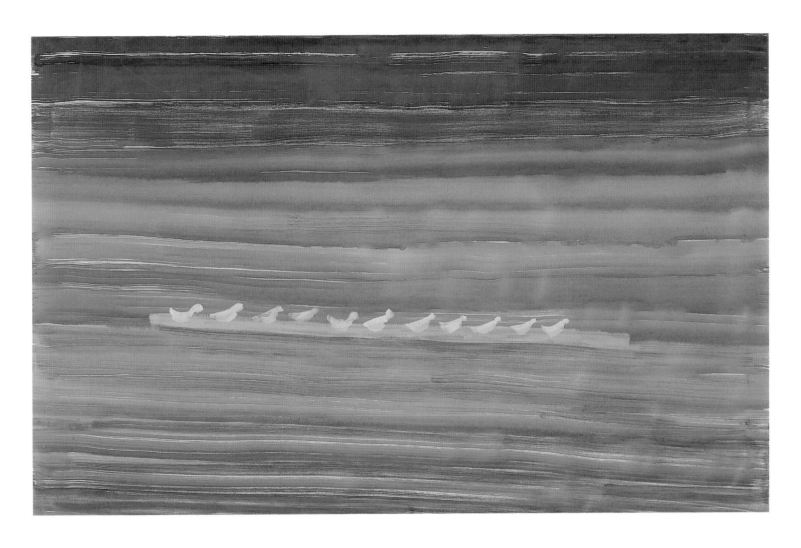

PLATE 48. *SEABIRDS ON A SANDBAR*, 1960

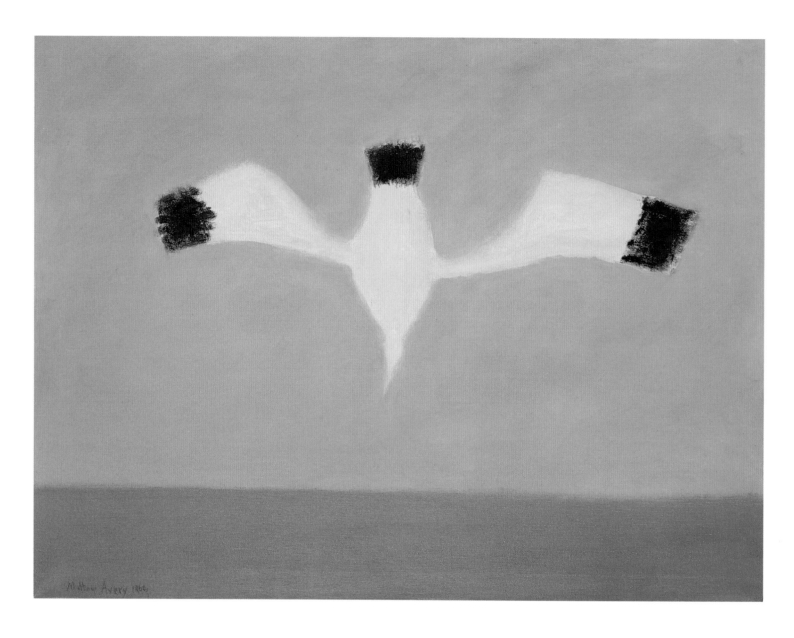

PLATE 49. *PLUNGING GULL,* 1960

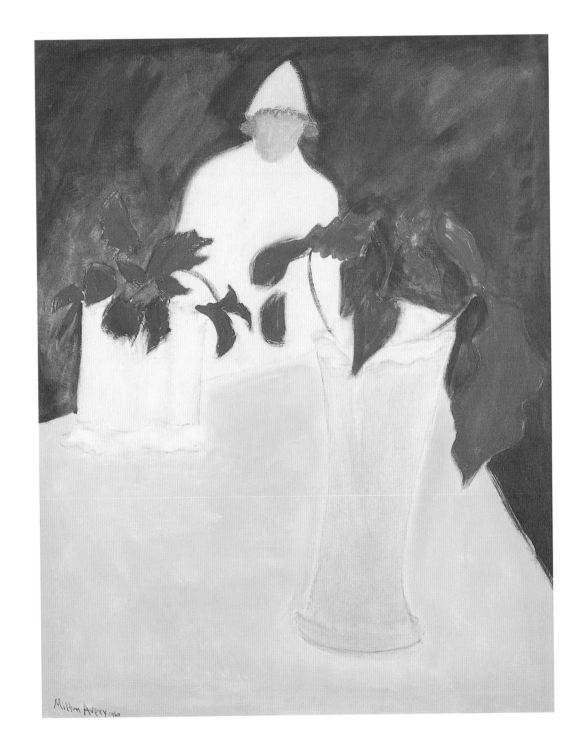

PLATE 50. *WHITE VASES, WHITE FIGURE*, 1960

PLATE 51. *BLUE BAY AND DUNES*, 1961

PLATE 52. *WHITE NUDE #2, 1963*

NOTES

1. See Barbara Haskell, *Milton Avery* (New York: Harper & Row, Whitney Museum of American Art, September 16–December 5, 1982).

2. Adolph Gottlieb, in *A Small Retrospective Survey of Paintings and Drawings by Milton Avery* (San Francisco: Gallery Reese Palley, September 1968), n.p.

3. Mark Rothko, "Commemorative Essay," in Haskell, *Milton Avery*, p. 181.

4. Dore Ashton, "Milton Avery" in *Milton Avery: Mexico* (New York: Grace Borgenicht Gallery, February 5–March 3, 1983), p. 13.

5. An examination of Avery's pastiches of his fellow artists is found in Robert Hobbs, *Milton Avery* (New York: Hudson Hills Press, 1990), pp. 182, 202, 214 ff.

6. Stephanie Gordon Noland, in *Milton Avery: The Late Paintings (1958–1963)* (Irvine: Art Gallery, University of California, Irvine, February 16–March 14, 1971), was the first to discern a separate late period in Avery's work.

7. See also Hobbs, *Milton Avery*, passim.

8. Clement Greenberg, "Milton Avery," *Arts* 32 (December 1957): 40–45, rev. ed., in Greenberg, *Art and Culture* (Boston: Beacon Press, 1961).

9. Jennie Van Horne Greenberg, conversation with the author, November 6, 2000. Ms. Greenberg noted that her husband's horror at Pollock's action was so profound that for the rest of his life he regarded the Abstract Expressionist as a murderer.

10. According to Barbara Haskell, Avery subtracted eight years from his life when he met and married Sally Michel, who was substantially younger. She consulted a census report of 1892, the Averys' marriage license, and critical literature on Avery, which generally gives his birth date as 1893, and concluded that Avery was born in 1885. See Haskell, *Milton Avery*, p. 182. Greenberg thus would have thought of Avery as 64 years old, when in fact he was 72. Either date is impressive, if one is singled out as a leader of the next wave of painters.

11. Clement Greenberg read German and may possibly have known Alois Riegl's *Spätrömische Kunstindustrie* (1901, 1927), which posits a historical development from haptic (tactile) to optic art and suggests that the former connotes individuality and separation while the latter implies social cohesion. The former is evident in Renaissance and Baroque art, the latter in Impressionism. As we will see, Greenberg's understanding of Impressionism, which he was reevaluating in the 1950s in the context of the rightful history of modern art, had a major impact on his analysis of opticality.

12. See Marla Price, "Interview with Nathan Halper, Provincetown, 24 July 1978," in Marla Price, *Milton Avery—Early and Late* (Annandale-on-Hudson: Edith C. Blum Art Institute, Milton and Sally Avery Center for the Arts, Bard College, May 29–July 31, 1981), n. 15. Halper, owner of the HCE Gallery in Provincetown, recalled that Avery had told him in the late 1950s that he had decided to paint larger works "like the abstract boys." These works represent Avery's first concerted effort to create a body of large canvases, although in 1932 he had completed *The Chariot Race*, which was more than six feet wide. This work indicates Avery's ambitions at the time, but his paintings tended to be much smaller until 1957, when he spent the summer in Provincetown. Probably his renewed contacts with Adolph Gottlieb, who was working on a much larger scale, had an impact on him.

13. Jennie Van Horne Greenberg, telephone conversation with the author, April 24, 2000. She and her husband, Clement, saw the Averys socially, and regarded him as a major artist. Hofmann also considered Avery an important colorist. According to Harvey S. Shipley Miller, "Hans Hofmann said that Avery was one of the few artists to understand color as a creative mean. He knew how to handle color in a plastic way." See Miller, "Some Aspects of the Work of Milton Avery," in *Milton Avery, Drawings & Paintings* (Austin: University of Texas, December 5, 1976–February 6, 1977), p. 6.

14. See Barbara Rose, *Frankenthaler* (New York: Harry N. Abrams, 1971), p. 260.

15. A number of reviewers and essayists took a cue from Greenberg's article. In an early, important monograph on Avery, Hilton Kramer cited Greenberg's analysis of Avery's relationship to Cubism: "He is one of the very few modernists of note in his generation to have disregarded Cubism." Hilton Kramer, *Milton Avery: Painting 1930–1960* (London: Thomas Yoseloff, 1962), p. 11. In his review of Avery's retrospective at the Whitney, Donald Kuspit, who has written a monograph on Greenberg, follows this critic's assessment that Avery is better as a landscapist than a figure painter. See Donald Kuspit, "Milton Avery," *Artforum* 21 (February 1983), pp. 77–78.

16. Pierre Bourdieu, *The Field of Cultural Production*, ed. Randal Johnson (New York: Columbia University Press, 193).

17. Greenberg, "Milton Avery," p. 43.

18. For a discussion of Pollock's interest in Ryder, see Claude Cernuschi, *Jackson Pollock: Meaning and Significance* (New York: Harper Collins, 1992), pp. 23 ff.

19. Winthrop Sargeant, "Nocturnal Genius," *Life* 30: 8 (February 26, 1951), p. 102. Sargeant used a number of the favored epithets, including "last of the romanticists" and "great native painter."

20. A[line] B. L[ouchheim], "Ryder: The Best American Painter's Largest Show," *Art News* 46: 9 (November 1947), p. 31.

21. Ibid., p. 30.

22. Ibid., p. 31.

23. Clement Greenberg, "American-Type Painting," in John O'Brian, ed., *Clement Greenberg: The Collected Essays and Criticism*, vol. 3, *Affirmations and Refusals 1950–1956* (Chicago: University of Chicago Press, 1986), pp. 217–36; *Partisan Review* 22: 2 (Spring 1955), 179–96, repr.

24. Ibid., p. 229.

25. For more information regarding Avery's political affiliations in the 1930s, see Hobbs, *Milton Avery*, pp. 101 ff.

26. Greenberg, "Milton Avery," p. 41.

27. Hilton Kramer, "Month in Review," *Arts* 31: 2 (November 1956): pp. 52–54.

28. John Canaday, *Mainstreams of Modern Art* (New York: Holt, Rinehart, and Winston, 1959), pp. 188–89.

29. Irving Sandler, *The New York School: The Painters and Sculptors of the Fifties* (New York: Harper & Row, 1978), p. 55.

30. John Hallmark Neff, "A Barnett Newman for Detroit," *Bulletin of the Detroit Institute of Art* 56: 3 (1978), p. 167, n. 24: "Mrs. Newman told me of her husband's wish to translate Laforgue, presumably from his *Mélanges posthumes*."

31. Robert Rosenblum, "Varieties of Impressionism," *Arts Digest* 29: 1 (October 1954), p. 7.

32. Thomas B. Hess, "Monet: Tithonus at Giverny," *Art News* 55 (October 1956), p. 42.

33. S[tuart] P[reston], "About Art and Artists," *New York Times*, November 30, 1955, p. 38.

34. Greenberg, "American-Type Painting," p. 228.

35. Clement Greenberg, "The Later Monet," *Art News Annual* 26 (1957), pp. 132–48.

36. Louis Finkelstein, "New Look: Abstract Impressionism," *Art News* 55: 1 (March 1956), pp. 36–39, 66–68.

37. Elaine de Kooning, "Subject: What, How or Who?" *Art News* 54: 2 (April 1955): pp. 26–29, 61–62.

38. Fairfield Porter, "American Non-Objective Painting," in *The Nation*, October 3, 1959, repr. in Rackstraw Downes, ed., *Fairfield Porter: Art in Its Own Terms: Selected Criticism 1935–1973* (New York: Taplinger, 1979), p. 56.

39. Finkelstein, "New Look," pp. 36, 37, 67.

40. Kramer, "Month in Review," p. 54.

41. Jules Laforgue, "Impressionism: The Eye and the Poet," *Art News* 55: 3 (May 1956), pp. 43–44.

42. Fairfield Porter, "Against Idealism," in *Art and Literature*, no. 2 (summer 1964), repr. in Downes, ed., *Fairfield Porter*, pp. 105, 106.

43. Greenberg, "Milton Avery," p. 41.

44. Important contributions to the study of American Impressionism are Charles Eldridge, "The Connecticut Impressionist: The Spirit of Place," *Art in America* 62: 5 (September–October 1974): pp. 85–90; William H. Gerdts, *American Impressionism* (New York: Abbeville Press, 1984); Donelson F. Hoops, *The American Impressionists* (New York: Watson-Guptill, 1972); Lisa N. Peters, "Cultivated Wilderness and Remote Accessibility: American Impressionist Views of the Home and Its Grounds" and David Schuyler, "Old Dwellings, Traditional Landscapes: Impressionist Artists and the Rediscovery of American Places," both in Lisa N. Peters, *American Impressionist Images of Suburban Leisure and Country Comfort* (Carlisle, Pa.: Trout Gallery, Dickinson College, 1997).

45. [Wallace Putnam], "Art," *Hartford Courant*, 1924, clipping in Milton Avery scrapbook, Avery Papers, New York.

46. The artist's wife, Sally Michel, recalls this fact. See "The Reminiscences of Sally Michel Avery: Interviews with Louis Schaeffer," Ms., Oral History Research Office, Columbia University, 1978, p. 11.

47. Peters, *American Impressionist Images of Suburban Leisure and Country Comfort*, pp. 12–13.

48. Elaine Tyler May, *Homeward Bound: American Families in the Cold War Era* (New York: Basic Books, 1988).

49. Ibid., p. 165.

50. Ibid., pp. 23, 24.

51. March Avery, telephone conversation with the author, April 21, 2000. Ms. Avery confirmed that she is left-handed.

52. Plato, *Cratylus, Parmenides, Greater Hippias, Lesser Hippias,* ed. H. N. Fowler (Cambridge: Harvard University Press, 1926, Loeb Classical Library), p. 165.

53. "Modern Art View Explained by Artists," *Hartford Courant*, January 3, 1931, clipping in Milton Avery scrapbook, Avery Papers.

54. Greenberg, "Milton Avery," p. 44. Except for small editorial changes, Greenberg's revised text is essentially the same as his first one. The change in emphasis of the last phrase in the second edition is worthy of note. It reads: ". . . but rarely has the necessity of exactness covered as much as it does in Avery's case."

55. W. J. T. Mitchell, "Imperial Landscape," *Landscape and Power* (Chicago: University of Chicago Press, 1994), pp. 5–34.

56. Greenberg, "Milton Avery," p. 44.

57. De Kooning, "Subject," pp. 26, 28.

58. Ibid., p. 27. Avery plays with this idea when he creates the visual pun of Abstract Expressionist internal nature as the external landscape surrounding his *Outdoor Sketcher* (1957).

59. Ibid., p. 28.

60. Fairfield Porter, "Tradition and Originality," *The Nation*, April 29, 1961, repr. in Downes, ed., in *Art in Its Own Terms*, pp. 121–24.

61. Ibid., p. 122.

62. See Alfred H. Barr, Jr., *Cubism and Abstract Art* (New York: Museum of Modern Art, 1936, repr. Arno Press, 1966). The reprint includes Barr's diagram and a frontispiece "reproduced from the jacket of the original edition."

63. David Riesman, in collaboration with Revel Denney and Nathan Glazer, *The Lonely Crowd: A Study of the Changing American Character* (New Haven: Yale University Press, 1967).

64. Greenberg, "Milton Avery," p. 41. Greenberg's revised edition condenses this idea: "On the other hand, his employment of abstract means for ends—which, however subtly or subduedly naturalistic, are nevertheless intensely so—is nothing if not American."

65. Ibid.

66. Ibid.

67. Ibid., p. 43.

68. "New Exhibitions of the Week: Roundabout the Galleries, Ten New Exhibitions," *Art News* 36 (April 16, 1938), p. 15.

69. Wallace Putnam, *Three Heroes I Have Known*, unpublished ms., n.d., p. 9. Barnes was not purchasing Avery's work for a museum. The year before, Duncan Phillips had acquired his *Seaport* for the Phillips Memorial Gallery, later the Phillips Collection, in Washington, D.C. 70. R[osamund] F[rost], "Milton Avery, American Fauve," *Art News* 41: 5 (December 15, 1942), p. 28.

71. M[aude] R[iley], "Milton Avery," *Art Digest* 17 (July 1, 1943), p. 20. The two other reviews referred to in Riley's piece are Emily Genauer, "Milton Avery Gains in Stature," *New York World-Telegram* (June 5, 1943), p. 4, and Edward Alden Jewell, "In the Realm of Art: Spring Slows to a Decorous Pace," *New York Times*, June 6, 1943, p. 9.

72. "Reminiscences of Sally Michel Avery," 1980, p. 40.

73. Although this fierce competition can be discerned in a number of Avery chronologies, this is the first time that it is used to diagnose Avery's critical reputation as the major American Fauve in the 1940s.

74. The title of a January 1945 review of Avery's shows at Durand-Ruel and Rosenberg by Maude Riley, "Milton Avery Fills an International Gap," plays on this perceived lacuna. See *Art Digest* 19: 8 (January 15, 1945), p. 10.

75. We ought to consider this new ideology when assessing the French and Surrealist aspects of early Abstract Expressionism.

76. Barbara Guest, "Avery and Gatch: Lonely Americans," *Art News* 59 (March 1960), p. 42.

77. For a further discussion of Sally Michel and her contributions to Milton Avery's art, see Robert Hobbs, "Sally Michel: The Other Avery," *Woman's Art Journal* 8: 2 (Fall 1987–Winter 1988), pp. 3–14.

78. "Reminiscences of Sally Michel Avery," 1978, p. 79.

79. "The Quiet One," *Time* 95 (March 16, 1970), p. 61.

80. "Reminiscences of Sally Michel Avery," 1980, pp. 22 ff.

81. James R. Mellow, "Sun, Surf and Subversion," *Art News* 81: 10 (December 1982), p. 80.

82. "Appendix A: Matisse Speaks to His Students, 1908: Notes by Sarah Stein," in Alfred H. Barr, Jr., *Matisse: His Art and His Public* (New York: Museum of Modern Art, 1951), pp. 550–52. This reprint of Stein's notes is the most accessible today.

83. Ibid., p. 550.

84. Greenberg, "Milton Avery," p. 43. In his second version, Greenberg dispenses with the word "patchwork." His edited text condenses the text: "And for all the inspired distortion and simplification of contour, factual accidents of the silhouette will intrude in a way that disrupts the flat patterning which is all-important to this kind of painting."

85. *Hartford Courant*, 1931, n.p., clipping in Milton Avery scrapbook, Avery Papers, New York.

86. Chris Ritter, "A Milton Avery Profile," *Art Digest* (December 1, 1952), p. 28.

87. Ibid., pp. 551–52.

88. "The Compleat Avery," *Art Digest* 27 (December 1, 1952), p. 14.

89. In Barr, *Matisse*, p. 550.

90. *Hartford Courant*, 1931, n.p.

91. In Barr, *Matisse*, p. 550.

92. "Contemporary American Painting" (Urbana, Ill.: College of Fine and Applied Art, University of Illinois, March 2–April 13, 1952), n.p.

93. Ibid.

94. In Barr, *Matisse*, p. 552.

95. Ferdinand de Saussure, *Course in General Linguistics*, trans. Wade Baskin (New York: McGraw-Hill, 1966), pp. 121, 123.

96. An undated clipping in the Milton Avery scrapbook, Avery Papers, titled "Artists Let Their Long Hair Down," refers to the third Woodstock Art Conference. It contains a photograph of Milton and March Avery in front of *Lanky Nude*. The caption reads, "Milton Avery compares his nude with live model—his daughter March."

97. "Reminiscences of Sally Michel Avery," 1980, p. 23.

98. This and following citations are from Greenberg, "Milton Avery," pp. 44, 45.

99. In the revised essay, Greenberg attends to possible misreadings of the decorative by qualifying it as the "pejoratively decorative."

100. Since the concluding paragraph of the first version of Greenberg's essay on Avery differs substantially from the second, I cite the closure of the former in its entirety: "Avery's latest landscapes, done in Provincetown this past summer, attest to a new and more magnificent flowering of his art. They were scantly and one-sidedly represented in his show at Borgenicht's. But then Avery has always been served badly by his exhibitions, which tend to reflect the inadequacies of his dealers rather than those of his art. To know his work in all its considerable range and variety, one has to see it in his studio. This may explain, in part, the unevenness of his reputation. Painters and even collectors have paid more attention to him than critics or museum people. I feel that not only should he be shown better but that he should be shown in larger quantity. It is time he were [*sic*] given a full-scale retrospective by a New York museum, not for the sake of his reputation, but for the sake of the situation of art in New York. The latest generation of abstract painters in New York has certain salutary lessons to learn from him that they cannot learn from any other artist on the scene."

101. Henry McBride, "Attractions in the Galleries," *New York Sun*, March 16, 1935, p. 32. The reference seemed apt to Marian Murray. In her review, "Art Show Gives Fling to Youth," she repeated McBride's analogy. *Hartford Times*, March 1935, n.p., clipping in Milton Avery scrapbook, Avery Papers, New York.

102. Henry McBride, "Attractions in Other Galleries," *New York Sun*, February

29, 1936, p. 26.

103. "Reminiscences of Sally Michel Avery," 1980, p. 27.

104. Sally Michel Avery, conversation with the author, October 6, 1986.

105. Ibid.

106. In his later years, Stevens put together a modest collection of paintings by minor School of Paris painters. His taste in painting, unlike his appreciation of poetry, seems to have been conservative.

107. Stevens read and wrote French with ease. He read Mallarmé early in his career, but later considered the French poet's influence on his own work modest, though he did not discount it entirely. In a May 3, 1949, letter to Bernard Heringman, he wrote, "Mallarmé never in the world meant as much to me as all that in any direct way. Perhaps I absorbed more than I thought. Mallarmé was a good deal in the air when I was much younger. But so were other people, for instance, Samain. Verlaine meant a good deal more to me." See Holly Stevens, ed., *Letters of Wallace Stevens* (Berkeley: University of California Press, 1996), p. 636. "All that" is a reference to Hi Simons's article, "Wallace Stevens and Mallarmé," which appeared in *Modern Philology* 43 (May 1946), pp. 235–59.

108. March Avery, telephone conversation with the author, June 7, 1999. Her father's library was broken up soon after his death, and no list of the contents was made. Avery was not a great letter writer, though he sent letters to his daughter at summer camp. She remembers these as particularly engaging, since they included drawings. Unfortunately, they are no longer extant. Avery was remarkable for his taciturnity and left only a few statements, which tend to focus on the pragmatics of making art.

109. Adelyn D. Breeskin, "Swans by Matisse," *American Magazine of Art* 28 (October 1935), pp. 622–29.

110. Ibid., p. 622.

111. Barr, *Matisse*, p. 245.

112. My reading is indebted to the superb interpretation provided by Henry Weinfield in *Stéphane Mallarmé: Collected Poems*, trans. and with commentary by Henry Weinfield (Berkeley: University of California Press, 1994), pp. 213–14.

113. Ibid., p. xiv.

114. Stéphane Mallarmé, "Crisis in Poetry," in *Mallarmé: Selected Prose Poems, Essays, & Letters*, trans. Bradford Cook (Baltimore: Johns Hopkins University Press, 1956), pp. 34–43.

115. Marcel Raymond, *From Baudelaire to Surrealism* (New York: Wittenborn, Schultz, 1950), p. 26.

116. Daniel-Henry Kahnweiler, "Mallarmé and Painting," in Raymond, *From Baudelaire to Surrealism*, p. 360. Mallarmé comments further: "There is a certain matter-of-factness about visual perception and painting techniques (whose principal sin is to mask the origin of this art which is made of oils and colors) which, though positive, can tempt those fools who are seduced by an appearance of facility, when seen in an over-simplified way."

117. Wallace Stevens, "The Man with a Blue Guitar," in Holly Stevens, ed., *The Palm at the End of the Mind: Selected Poems and a Play by Wallace Stevens* (New York: Vintage, 1972), p. 133. This reading draws substantially on that formulated in Robert Hobbs, *Milton Avery*, pp. 153 ff.

118. Wallace Stevens, "Notes Toward a Supreme Fiction," in *The Collected Poems of Wallace Stevens* (New York: Alfred A. Knopf, 1954, repr. 1975), p. 380.

119. Ibid., p. 381.

120. Ibid.

121. Ibid., p. 385.

122. Ibid., p. 407.

123. Ibid., p. 382.

124. Ibid., p. 387.

125. Ibid., p. 396.

126. Ibid., p. 382.

127. "An Interview with Milton Avery," *Art Students League Bulletin*, April 1943.

128. *The Milton Avery Family* (New Britain, Conn.: New Britain Museum of American Art, November 1968).

129. "Reminiscences of Sally Michel Avery," 1980, p. 125.

130. For an extended discussion of Avery's relationship to American folk art, see Hobbs, *Milton Avery*, pp. 68–84.

131. Dorothy Gees Seckler, "A Very Nice Avery," *Art News* 51 (December 1952), p. 60.

132. D[onald] J[udd], "In the Galleries: Milton Avery," *Arts* 38 (December 1963), p. 61.

133. "Seaside Painting," *Time* 72 (September 15, 1958), p. 72.

134. "Reminiscences of Sally Michel Avery," 1978, pp. 65 ff.

135. "Milton Avery" (Naples, Fla., Harmon Gallery, March 14–April 3, 1982).

LIST OF PLATES

Works not in the exhibition are indicated by an asterisk ().*
Not all works in the exhibition can be seen at all venues.

PLATE 1. *ADOLESCENCE*, 1947
OIL AND GRAPHITE ON CANVAS, 30 x 40 INCHES
TERRA FOUNDATION FOR THE ARTS; DANIEL J. TERRA COLLECTION,
CHICAGO (1992.3)

PLATE 2. *BOW RIVER*, 1947
OIL ON CANVAS, 46 x 32 INCHES
PRIVATE COLLECTION

PLATE 3. *RED ROCK FALLS*, 1947
OIL ON CANVAS, 37⅞ x 43⅞ INCHES
MILWAUKEE ART MUSEUM; GIFT OF MRS. HARRY LYNDE BRADLEY
(M1977.70)

PLATE 4. *OREGON COAST*, 1947
OIL ON CANVAS, 36 x 46 INCHES
PRIVATE COLLECTION

PLATE 5. *WHITE SEA*, 1947
OIL ON CANVAS, 31¼ x 39¼ INCHES
COLLECTION BERTA BORGENICHT KERR

PLATE 6. *THE HAIRCUT*, 1947
OIL ON CANVAS, 44 x 32 INCHES
COLLECTION JANE BRADLEY PETTIT, MILWAUKEE

PLATE 7. *SELF-PORTRAIT*, 1947
OIL ON CANVAS, 55 x 36 INCHES
MILTON AVERY TRUST

PLATE 8. *NUDE IN BLACK ROBE*, 1950
OIL ON CANVAS, 36 x 28 INCHES
PRIVATE COLLECTION, PRINCETON, NEW JERSEY

PLATE 9. *SUMMER READER*, 1950
OIL ON CANVAS, 34 x 44 INCHES
THE ROLAND COLLECTION

PLATE 10. *CHAIR WITH LILACS*, 1951
OIL ON CANVAS, 36 x 28 INCHES
COLLECTION BERTA BORGENICHT KERR

PLATE 11. *ORANGE VASE*, 1951
OIL ON CANVAS, 40 x 30 INCHES
COLLECTION J. BLACK AND R. SCHLOSBERG

PLATE 12. *MARCH ON THE BALCONY*, 1952
OIL ON CANVAS, 44 x 34 INCHES
THE PHILLIPS COLLECTION, WASHINGTON, D.C. (0039)

PLATE 13. *SHEEP*, 1952
OIL ON CANVAS, 30 x 40 INCHES
MILTON AVERY TRUST

PLATE 14. *SUNSET*, 1952
OIL ON CANVAS, 42½ x 48⅛ INCHES
BROOKLYN MUSEUM OF ART, NEW YORK; GIFT OF ROY R. AND
MARIE S. NEUBERGER FOUNDATION, INC. (58.40)

PLATE 15. *SHAPES OF SPRING*, 1952
OIL ON CANVAS, 34 x 38 INCHES
COLLECTION MR. AND MRS. WALTER KANN

PLATE 16. *BREAKING SEA*, 1952
OIL ON CANVAS, 30 x 40 INCHES
THE BALTIMORE MUSEUM OF ART; FREDERIC W. CONE FUND
(1953.227)

PLATE 17. *ADVANCING SEA*, 1953
OIL ON CANVAS, 42 x 48 INCHES
MILTON AVERY TRUST

PLATE 18. *EXCURSION ON THE THAMES*, 1953
OIL ON CANVAS, 40 x 50 INCHES
MILTON AVERY TRUST

PLATE 19. *THE SEINE*, 1953
OIL ON CANVAS, 41 x 50 INCHES
WHITNEY MUSEUM OF AMERICAN ART, NEW YORK; PURCHASE,
WITH FUNDS FROM AN ANONYMOUS DONOR (54.33)

PLATE 20. *HARVEST*, 1953
OIL ON CANVAS, 33 x 44 INCHES
PRIVATE COLLECTION, NORTHAMPTON, MASSACHUSETTS

PLATE 21. *SPRING IN NEW HAMPSHIRE*, 1954
OIL ON CANVAS, 34 x 58 INCHES
MILTON AVERY TRUST

PLATE 22. *WATERFALL*, 1954
OIL ON CANVAS, 32 x 52 INCHES
NEUBERGER MUSEUM OF ART, PURCHASE COLLEGE, STATE
UNIVERSITY OF NEW YORK, PURCHASE; GIFT OF ROY R. NEUBERGER
(1969.01.11)

PLATE 23. *DARK STILL LIFE*, 1954
OIL ON CANVAS, 38 x 46 INCHES
NORTON MUSEUM OF ART, WEST PALM BEACH, FLORIDA;
PURCHASED THROUGH THE R. H. NORTON FUND (61.13)

PLATE 24. *HINT OF AUTUMN*, 1954
OIL ON CANVAS, 53 x 34 INCHES
COLLECTION SANDY AND HAROLD PRICE, LAGUNA BEACH,
CALIFORNIA

PLATE 25. *BICYCLE RIDER BY THE LOIRE*, 1954
OIL ON CANVAS, 38 x 55 INCHES
FLINT INSTITUTE OF ARTS, MICHIGAN; BEQUEST OF MARY MALLERY
DAVIS (1990.19)

PLATE 26. *SEA AND SAND DUNES*, 1955
OIL ON CANVAS, 40 x 60 INCHES
PRIVATE COLLECTION, NORTHAMPTON, MASSACHUSETTS

PLATE 27. *THE WHITE WAVE*, 1956
OIL ON CANVAS, 30 x 42 INCHES
HERBERT F. JOHNSON MUSEUM OF ART, CORNELL UNIVERSITY,
ITHACA, NEW YORK; GIFT OF HELEN HOOKER ROELOFS IN MEMORY
OF HER FATHER, ELON HUNTINGTON HOOKER, CLASS OF 1896
(73.067)

PLATE 28. *NUDE COMBING HAIR*, 1954
OIL ON CANVAS, 50 x 34 INCHES
PRIVATE COLLECTION, NORTHAMPTON, MASSACHUSETTS

PLATE 29. *POETRY READING*, 1957
OIL ON CANVAS, 43¾ x 56 INCHES
MUNSON-WILLIAMS-PROCTOR INSTITUTE, MUSEUM OF ART, UTICA,
NEW YORK (59.8)

PLATE 30. *MADONNA OF THE ROCKS*, 1957
OIL ON CANVAS, 50 x 40 INCHES
COLLECTION MARTIN AND LINDA WEISSMAN, BIRMINGHAM,
MICHIGAN

PLATE 31. *TWO FIGURES*, 1957
OIL ON CANVAS, 38 x 51 INCHES
COLLECTION LOIS BORGENICHT

*PLATE 32. *WHITE MOON*, 1957
OIL ON CANVAS, 50 x 38 INCHES
PRIVATE COLLECTION

PLATE 33. *DARK MOUNTAIN*, 1958
OIL ON CANVAS, 60 x 72 INCHES
MILTON AVERY TRUST

PLATE 34. *OFFSHORE ISLAND*, 1958
OIL ON CANVAS, 46 x 56 INCHES
SHELDON MEMORIAL ART GALLERY AND SCULPTURE GARDEN,
UNIVERSITY OF NEBRASKA, LINCOLN; NAA–THOMAS C. WOODS
MEMORIAL (1960.N-125)

PLATE 35. *ONRUSHING WAVE*, 1958
OIL ON CANVAS, 54 x 72 INCHES
MILTON AVERY TRUST

PLATE 36. *SANDBAR AND SEABIRDS*, 1958
OIL ON CANVAS, 50 x 66 INCHES
MILTON AVERY TRUST

PLATE 37. *DUNES AND SEA I*, 1958
OIL ON CANVAS, 54 x 72 INCHES
CARNEGIE MUSEUM OF ART, PITTSBURGH; PURCHASE: GIFT OF
KAUFMANN'S DEPARTMENT STORE, THE WOMEN'S COMMITTEE,
EDITH H. FISHER FUND, FELLOWS FUND, JAMES A. FISHER, THE
HENRY HILLMAN FUND, MR. AND MRS. LEON D. BLACK, MR. AND
MRS. ROBERT H. FALK, MRS. GRACE BORGENICHT BRANDT, THE
JEANETTE AND SAMUEL LUBELL FOUNDATION, AND THE MORTON
FOUNDATION, 1983 (83.5)

PLATE 38. *SEA GRASSES AND BLUE SEA*, 1958
OIL ON CANVAS, 60 1/8 x 72 3/8 INCHES
THE MUSEUM OF MODERN ART, NEW YORK; GIFT OF FRIENDS OF
THE ARTIST (649.59)

PLATE 39. *DARK FOREST*, 1958
OIL ON CANVAS, 40 x 53 INCHES
COLLECTION DONALD AND FLORENCE MORRIS, HUNTINGTON
WOODS, MICHIGAN

PLATE 40. *BOATHOUSE BY THE SEA*, 1959
OIL ON CANVAS, 72 x 60 INCHES
MILTON AVERY TRUST

PLATE 41. *STORMY DAY*, 1959
OIL ON MASONITE, 24 1/8 x 30 INCHES
MILWAUKEE ART MUSEUM, WISCONSIN; GIFT OF MRS. HARRY
LYNDE BRADLEY (M1977.200)

PLATE 42. *TANGERINE MOON AND WINE
DARK SEA*, 1959
OIL ON CANVAS, 60 x 72 INCHES
COLLECTION SIDNEY AND MADELINE FORBES

PLATE 43. *BLACK SEA*, 1959
OIL ON CANVAS, 50 x 67 3/4 INCHES
THE PHILLIPS COLLECTION, WASHINGTON, D.C. (0035)

PLATE 44. *BLACK NIGHT*, 1959
OIL ON CANVAS, 52 x 34 INCHES
MILTON AVERY TRUST

PLATE 45. *INTERLUDE*, 1960
OIL ON CANVAS, 68 x 58 INCHES
PHILADELPHIA MUSEUM OF ART; GIVEN BY THE WOODWARD
FOUNDATION: CENTENNIAL GIFTS, 1975 (1975–087–001)

PLATE 46. *MOUNTAIN AND MEADOW*, 1960
OIL ON CANVAS, 60 x 68 INCHES
NATIONAL GALLERY OF ART, WASHINGTON, D.C.; GIFT OF
SALLY MICHEL AVERY, IN HONOR OF THE 50TH ANNIVERSARY OF THE
NATIONAL GALLERY OF ART (1991.52.1)

PLATE 47. *ROBED NUDE*, 1960
OIL ON CANVAS, 68 x 58 INCHES
PRIVATE COLLECTION, PRINCETON

PLATE 48. *SEABIRDS ON A SANDBAR*, 1960
OIL ON CANVAS, 34 x 54 INCHES
PHILADELPHIA MUSEUM OF ART; GIFT OF THE MILTON AVERY TRUST
(1944-053-001)

PLATE 49. *PLUNGING GULL*, 1960
OIL ON CANVAS, 30 x 40 INCHES
COLLECTION MARGO COHEN, COURTESY DONALD MORRIS GALLERY,
BIRMINGHAM, MICHIGAN

PLATE 50. *WHITE VASES, WHITE FIGURE*, 1960
OIL ON CANVAS, 40 x 32 INCHES
COLLECTION LOIS BORGENICHT

PLATE 51. *BLUE BAY AND DUNES*, 1961
OIL ON CANVAS, 40 x 50 INCHES
MILTON AVERY TRUST

PLATE 52. *WHITE NUDE #2*, 1963
OIL ON CANVAS, 50 x 40 INCHES
COLLECTION LYNN AND ALLEN TURNER, CHICAGO

BIBLIOGRAPHY

Ashton, Dore. "Milton Avery: A Painter's Painter at Borgenicht." *Arts* 42 (May 1968), pp. 34–35.

A *Small Retrospective Survey of Paintings and Drawings by Milton Avery*. San Francisco: Gallery Reese Palley, 1968. Statement by Adolph Gottlieb; commemorative essay by Mark Rothko; essay by James R. Mellow. Exhibition catalogue.

Avery, Sally M. "Painter's Life: Avery at Whitney." Interview by Patricia Bailey. *Art/World* (October 1982), pp. 1, 10.

Breeskin, Adelyn D. *Milton Avery*. New York: American Federation of Arts, 1960. Exhibition catalogue.

———. *Milton Avery*. Washington, D.C.: National Collection of Fine Arts, Smithsonian Institution, 1969. Exhibition catalogue.

"The Compleat Avery." *Art Digest* 27 (December 1, 1952), p. 14.

F[rost], R[osamund]. "Milton Avery, American Fauve." *Art News* 41 (December 15, 1942), p. 28.

Garver, Thomas H. "Los Angeles: Milton Avery—UNC, Irvine." *Artforum* 9 (April 1971), pp. 86–87.

Genauer, Emily. "Milton Avery Gains in Stature." *New York World-Telegram*, June 5, 1943, p. 4.

Grad, Bonnie Lee. *Milton Avery Monotypes*. Princeton, N.J.: Princeton University Library, 1977. Foreword by O. J. Rothrock. Exhibition catalogue.

———. *Milton Avery*. Royal Oak, Mich.: Strathcona, 1981.

Greenberg, Clement. "Milton Avery." *Arts* 32 (December 1957): 40–45. Rev. in *Art and Culture: Critical Essays*. Boston: Beacon Press, 1961; repr. in *Milton Avery*. London: Waddington Galleries, 1962.

Hartford Courant, 1931. Untitled clipping in Milton Avery scrapbook, Avery Papers, New York.

Hartley, Marsden. "On the Persistence of the Imagination: The Painting of Milton Avery, American Imaginative." In *Marsden Hartley: On Art*. Edited by Gail R. Scott. New York: Horizon Press, 1982.

Haskell, Barbara. "Milton Avery: Why Talk When You Can Paint." *Portfolio* 4 (September–October 1982), pp. 76–81.

———. *Milton Avery*. New York: Whitney Museum of American Art, 1982. Exhibition catalogue.

Hobbs, Robert. *Milton Avery*. New York: Hudson Hills Press, 1990.

———. "Sally Michel: The Other Avery." *Woman's Art Journal* 8: 2 (Fall 1987–Winter 1988), pp. 3–14.

"An Interview with Milton Avery." *Art Students League Bulletin*, April 1943.

Jewell, Edward Alden. "In the Realm of Art: Spring Slows to a Decorous Pace." *New York Times*, June 6, 1943, p. 9.

J[udd], D[onald]. "In the Galleries." *Arts* 38 (December 1963), p. 61.

Kahn, Wolf. "Milton Avery's Good Example." *Art Journal* 43 (Spring 1983), pp. 87–89.

Kramer, Hilton. *Milton Avery: Paintings, 1930–1960*. New York: Thomas Yoseloff, 1962.

———. "Month in Review." *Arts* 31: 2 (November 1956), p. 52.

Kuspit, Donald. *Artforum* 21 (February 1983), pp. 77–78.

Makler, Paul Todd. "Milton Avery." *Prometheus* (September 1961), pp. 21–24.

McBride, Henry. "Attractions in the Galleries." *New York Sun*, March 16, 1935, p. 32.

———. "Attractions in Other Galleries." *New York Sun*, January 23, 1932, p. 5.

Mellow, J. R. "Sun, Surf and Subversion." *Art News* 81: 10 (December 1982), pp. 78–80.

Milton Avery: Avery in Mexico and After. Houston, Tex.: Sarah Campbell Blaffer Gallery, University of Houston, 1981. Introduction by Sally M. Avery; essays by Dore Ashton, Fernando Gamboa, Carla Stellweg, and Salvador Elizondo. Exhibition catalogue.

Milton Avery: Drawings and Paintings. Austin: University of Texas, 1976. Introduction by Earl A. Powell III; essay by Harvey S. Shipley Miller. Exhibition catalogue.

Milton Avery: Early Promise, Late Fulfillment. New York: Grace Borgenicht Gallery, 1995. Exhibition catalogue.

Milton Avery, 1893–1965. Birmingham, Ala.: Birmingham Museum of Art, 1968. Note by Helen Boswell. Exhibition catalogue.

Milton Avery, 1893–1965. Lincoln, Nebr.: Sheldon Memorial Art Gallery, 1966. Introduction by Norman A. Geske; essay by Frank Getlein. Exhibition catalogue.

Milton Avery in the Forties. New York: Grace Borgenicht Gallery, 1979. Essay by Carter Ratcliff, 1979. Exhibition catalogue.

Milton Avery: Late Paintings (1958–1963). Irvine, Calif.: Art Gallery, University of California, Irvine, 1971. Introduction by Stephanie Gordon Noland. Exhibition catalogue.

Milton Avery. London: Waddington Galleries, 1962. Essay by Clement Greenberg, repr. from *Arts* 32 (December 1957). Exhibition catalogue.

Milton Avery. Louisville, Ky.: Allen R. Hite Art Institute, University of Louisville, 1965. Exhibition catalogue.

Milton Avery: Mexico. New York: Grace Borgenicht Gallery, 1983. Essay by Dore Ashton. Exhibition catalogue.

Milton Avery. Naples, Fla.: Harmon Foundation, 1982. Exhibition catalogue.

Milton Avery: The 1940's Period. Milwaukee, Wis.: David Barnett Gallery, 1989. Exhibition catalogue.

Milton Avery: Paintings from the Collection of the Neuberger Museum of Art. Purchase, N.Y.: Neuberger Museum of Art, Purchase College, State University of New York, 1994. Essay by Barbara Haskell. Exhibition catalogue.

Milton Avery: Paintings, 1941–1963. Detroit: Donald Morris Gallery, 1966. Introduction by Alicia Legg. Exhibition catalogue.

Milton Avery: Progressive Images. Boise, Idaho: Boise Art Museum, 1988. Introduction by Dennis O'Leary and Sandy Harthorn; essay by Marla Price. Exhibition catalogue.

Milton Avery's Mexico. Memphis, Tenn.: Dixon Gallery and Gardens, 1984. Foreword by Sally M. Avery; introduction by Frank Getlein. Exhibition catalogue.

Milton Avery: Works from the 1950s. Fort Worth, Tex.: Modern Art Museum of Fort Worth, 1990. Exhibition catalogue.

Murray, Marrain. "Art Show Gives Fling to Youth." *Hartford Times,* March 1935. Clipping in Milton Avery scrapbook, Avery Papers, New York.

"New Exhibitions of the Week: Roundabout the Galleries, Ten New Exhibitions." *Art News* 36 (April 15, 1938), p. 15.

Price, Marla. *Milton Avery, Early and Late.* Annandale-on-Hudson, N.Y.: Edith C. Blum Art Institute, Milton and Sally Avery Center for the Arts, Bard College, 1981. Exhibition catalogue.

———. "The Paintings of Milton Avery." Ph.D. dissertation, University of Virginia, 1982.

Putnam, Wallace. *Three Heroes I Have Known.* Unpublished manuscript, n.d.

[Putnam, Wallace]. "Four Artist Exhibition at Wiley Gallery." *Hartford Courant,* October 1924.

"The Quiet One." *Time* 95 (March 16, 1970).

"The Reminiscences of Sally Avery: Interviews with Louis Schaeffer." Unpublished manuscript. Oral Research Office, Columbia University, 1978, 1980.

R[iley], M[aude]. "Milton Avery." *Art Digest* 17 (July 1, 1943), p. 20.

Ritter, Chris. "A Milton Avery Profile." *Art Digest* 27 (December 1, 1952), pp. 11–12, 28.

Sawin, Martica. "Milton Avery." *Museum Magazine* (September–October 1982), pp. 44–47.

Schwartz, Sanford. "The Avery Retrospective." *New Criterion* 1: 3 (November 1982), pp. 55–62.

The Sea by Milton Avery. Keene, N.H.: Louise E. Thorne Memorial Art Gallery, 1971. Foreword by Henry Geldzahler. Exhibition catalogue.

Swenson, May. "Milton Avery." *Art Yearbook* 3 (1959), pp. 108–13.

University of Illinois Exhibition of Contemporary American Painting. Urbana, Il.: University of Illinois Press, 1951. Essay by Allen S. Weller; biography by Edwin C. Rae. Exhibition catalogue.

Wasserman, Emily. "New York: Milton Avery, Brooklyn Museum." *Artforum* 8 (May 1970), pp. 77–78.

Wernick, Robert. "A Quiet American Painter Whose Art Is Now Being Heard." *Smithsonian* 13 (October 1982), pp. 110–17.

Wight, Frederick. S. *Milton Avery.* Baltimore, Md.: Baltimore Museum of Art, 1952. Exhibition catalogue.

Wilkin, Karen. *Milton Avery: Paintings of Canada.* Kingston, Ont.: Agnes Etherington Art Centre, Queen's University at Kingston, 1986. Foreword by Frank Getlein. Exhibition catalogue.

AMERICAN FEDERATION OF ARTS

Mr. and Mrs. Jeffrey Marcus

Mr. and Mrs. Tom Marsh

Mr. and Mrs. Robert Menschel

Mr. and Mrs. Eugene Mercy, Jr.

Mary S. Myers

Mrs. Peter Roussel Norman

Mr. and Mrs. George P. O'Leary

Patricia M. Patterson

Elizabeth Petrie

Mrs. Nicholas R. Petry

Mrs. Edward M. Pinsof

Mr. and Mrs. John W. Pitts

Mr. and Mrs. Harvey R. Plonsker

Mrs. Lawrence S. Pollock, Jr.

Mr. and Mrs. D. S. Reid

Mr. and Mrs. Jonathan P. Rosen

Mrs. Richard L. Rosenthal

Felice T. Ross

Mr. and Mrs. Lawrence Ruben

Mr. and Mrs. Rudi E. Scheidt

Mr. and Mrs. Paul C. Schorr, III

Adriana Seviroli

Mr. and Mrs. Eric P. Sheinberg

Mr. and Mrs. Michael Sheldon

Mr. and Mrs. Matthew R. Simmons

Dory Small

Susan Soros

Diana Lee and Leroy Stahlgren

Mr. and Mrs. Ronald Stern

Mrs. James G. Stevens

Mr. and Mrs. Harry F. Stimpson, Jr.

Linda Katzen Swartz

Mr. and Mrs. Jeff Tarr

Rosalie Taubman

Mr. and Mrs. Harry Tenenbaum

Mr. and Mrs. Marcel Timmermans

Mr. and Mrs. Armand Tob

Mr. and Mrs. Don Todd

Mr. and Mrs. William B. Troy

Baron and Baroness François van der Elst

Mr. and Mrs. van Renynghe

Mr. and Mrs. Roger Vanthournout

Mr. Emiel Veranneman

Mr. and Mrs. Richard Waitzer

Mrs. Robert C. Warren

Mr. and Mrs. Alan Weeden

Mrs. Richard Weil

Mr. and Mrs. Guy A. Weill

Mr. and Mrs. Eugene Worrell

Mrs. T. Evans Wyckoff

BENEFACTORS
CIRCLE

Mr. and Mrs. Steven Ames

Mr. and Mrs. Henry H. Ashforth

Mr. and Mrs. Glenn W. Bailey

Mr. and Mrs. Frank B. Bennett

Mr. and Mrs. Winslow W. Bennett

Mr. and Mrs. James Brice

Iris Cantor

Charles Cowles

Mr. and Mrs. Donald M. Cox

David L. Davies and John D. Weeden

Mr. and Mrs. Kenneth N. Dayton

Mr. and Mrs. C. Douglas Dillon

Mr. and Mrs. William Ethridge

Mrs. Donald Findlay

Mr. and Mrs. John A. Friede

Mr. and Mrs. Norman Hascoe

Mrs. Lee Hills

Mr. and Mrs. Theodore S. Hochstim

Mr. and Mrs. Richard S. Lane

Mr. and Mrs. Robert E. Linton

Mr. and Mrs. Henry Luce III

Jeanne Lang Mathews

Mr. and Mrs. Frederick R. Mayer

Mrs. C. Blake McDowell, Jr.

Mr. and Mrs. Robert M. Meltzer

Nancy B. Negley

Roy R. Neuberger

Honorable and Mrs. Leon B. Polsky

Mr. and Mrs. Milton F. Rosenthal

Barbara Slifka

Mr. and Mrs. Michael R. Sonnenreich

Ira Spanierman

Ann C. Stephens

Mr. and Mrs. John W. Straus

Mr. and Mrs. David J. Supino

Mr. and Mrs. Michael J. Waldman

Dianne Wallace and Lowell M. Schulman

Mr. and Mrs. Herbert Wittow

INDEX

PHOTOGRAPH CREDITS

Most photographs of works of art reproduced in this volume have been provided by the owners or custodians of the works and are reproduced by their permission. The following additional credits apply to the plate numbers indicated.

Courtesy Associated Press: fig. 14, page 31; fig. 28, page 59. Richard Carafelli, plate 46, page 93. Sheldan C. Collins, plate 19, page 48. G. R. Farley, plate 29, p. 74. Jim Frank, plate 22, pages 56–57. Courtesy Giraudon/Art Resource: fig. 29, page 60. David Heald, plate 4, page 17; plate 15, page 37. Image Ination, plate 9, page 25. Ed Owen, plate 12, page 32. Lynn Rosenthal, plate 45, page 92. Larry Sanders, plate 3, pages 14–15; plate 6, page 20. David Stansbury, plate 20, page 50; plate 41, page 88. Graydon Wood, plate 48, page 95.